EVERYDAY
WATERCOLOR
seashores

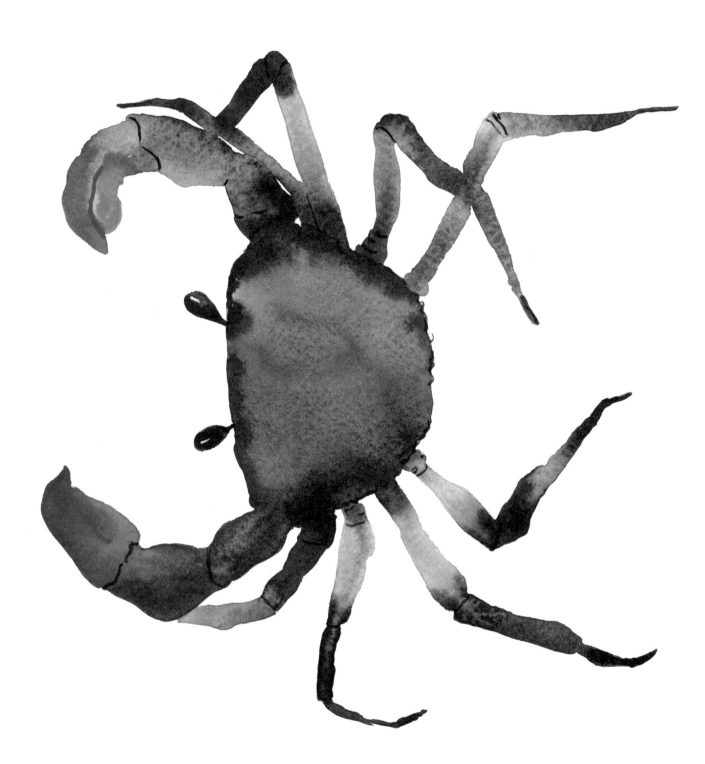

EVERYDAY WATERCOLOR
seashores

A MODERN GUIDE TO PAINTING SHELLS, CREATURES, AND BEACHES STEP BY STEP

Jenna Rainey

WATSON·GUPTILL
CALIFORNIA | NEW YORK

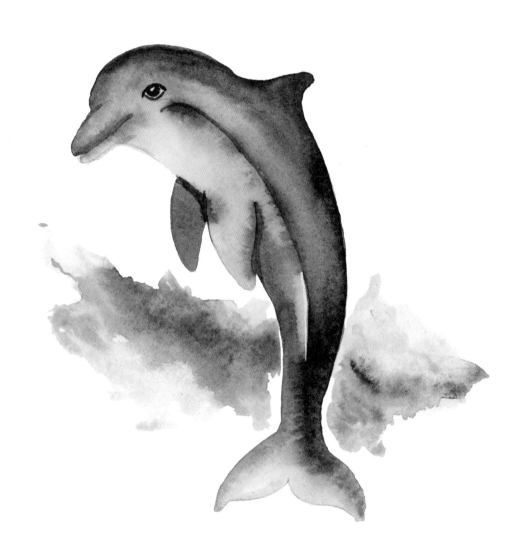

Contents

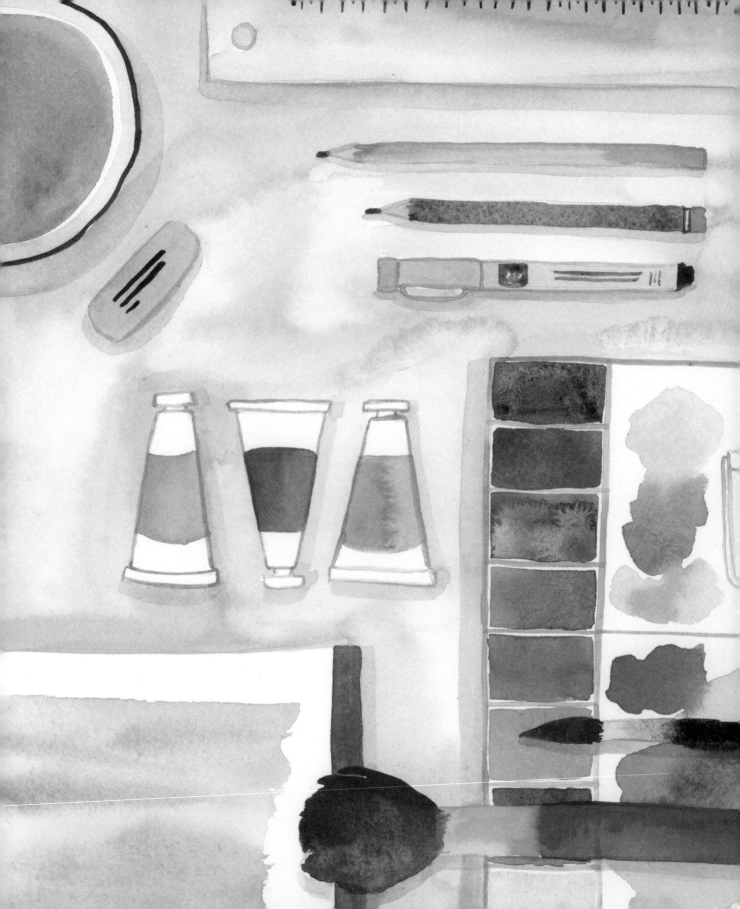

Introduction

The wet, sinking sand under your feet and water lapping at your toes. The salty air tickling your nose and sun baking into your skin. The sound of waves battering and rumbling . . . this is life near the ocean.

Because I grew up in a beach town, these sights, smells, and sounds are beloved sense memories for me. For many, the beach is a place to relax and break free from lives of overworking and busy schedules. For children, it's a wonderful place to create memories and discover new landscapes and creatures.

This landscape holds so much beautiful texture and color—not one beach or ocean looks exactly the same. The way the beach looks in the morning, enveloped by fog and stillness, transforms at sunset, rich with color, waves rhythmically rolling in all night. When I look at any ocean or walk any shore, I feel peace. When I encounter a starfish or see a dolphin in the distance, I am met with awe! It's a place full of life that is so inspiring to paint.

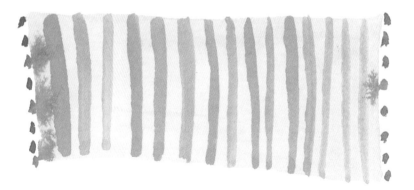

To me, the beach is not just paradise—it's a place to explore and learn, a place to be moved, a place to experience joy and tranquility. It is also a place to treasure and that should be treated with great respect. My hope is that anytime you paint an ocean landscape or creature, you are met with this vastness and complexity of emotion and inspiration. This feeling of being in "flow state" can be encountered more easily when you think of this landscape and all it holds as a majestic and holy place. It is big, it is beautiful, and the creatures that inhabit it are powerful and mysterious.

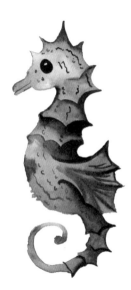

Although painting ocean creatures, plants, and landscapes may seem complex, my goal is to simplify and break down the techniques so you can focus on how amazingly fun it is to paint with watercolor. Watercolor and the beach? It's like they're meant for each other, right? A match made in heaven, if you ask me!

We'll start by working our way through all the technical stuff. You'll have less fun painting if you miss these fundamental guides and tips, so don't skip the introduction. Trust me!

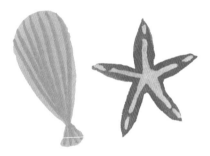

Each section of this book will cover a particular type of subject: seashells, plants and fishes, sea creatures, ocean scenes, and painterly landscapes. We'll cover different watercolor techniques and will begin with simple shapes that then become more complex. For example, we'll start with a circle and build on it to create a conch, or murex, shell. Understanding how to break complicated subjects down into simple shapes—whether you are using a reference photograph or working from life—will help you paint more confidently!

Throughout my years of teaching, I've found that many people, though skilled, lack confidence. My goal with this book is to simplify even the most complex-looking subjects so you can feel comfortable painting anything on your own. Painting is such a joyful experience, and if you put in the work on the basics you can accept and conquer new challenges as you grow in your painting practice.

TOOLS *of the* TRADE

Going to an art store to gear up on supplies can be intimidating if you're not sure what you like or what you're looking for. So, let me help with that! Here is the list of the supplies I use and recommend.

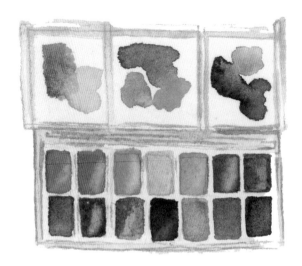

Paint

Watercolor paint can be purchased as either tubes of paint or dried color in pans. Both are commonly used and are available in either professional grade or student grade. One popular student-grade paint is Winsor & Newton's Cotman. Although the price tag on the Cotman paints may be tempting, do keep in mind that the quality of the pigment is not as pure and concentrated as professional-grade paints. Additionally, student-grade paints are usually grainier, not as transparent, and can become muddy faster than professional-grade pigments.

I work with MaimeriBlu, which is an Italian-made, professional-grade watercolor paint; I buy tubes and squeeze the paint onto my palette. I then let these colors dry overnight before I use them. I do this because I don't like to waste paint and have found that, at the scale I normally paint (no larger than 11 by 14 inches), a little bit of paint goes a long way! Using dried paint is best when what you're working on calls for only

a small amount of pigment, while working with paint straight from the tube is ideal for larger-scale painting when you need more coverage.

Something I get asked a lot is why I don't just buy a prefilled palette or pans of watercolor. Using tubes of paint gives me more colors to choose from and I can control how much paint I put in each well. If you're buying professional-level tubes and letting them dry on your palette, it will essentially be the same as buying pans of professional-level watercolor. However, a premade palette or pan set can be very convenient if you're traveling, as they are usually quite compact. Keep in mind, though, that the compact nature of these palettes makes it difficult to grab color with bigger brushes and you have limited space for mixing colors.

Color List and Key

Below is a list of colors that I always have in my palette (listed in order of placement). These pigments are all MaimeriBlu professional-grade watercolor and some are Winsor & Newton professional-grade. I've come to love each of these colors over the years and recommend them to all my students, but do be adventurous and try other brands and colors if your heart desires. Every artist is different and can be drawn to different palettes, intensities, and levels of quality. My preference is MaimeriBlu, but I used Winsor & Newton for years and below I provide a cross-reference for anyone using W&N versus MaimeriBlu.

Mars Black (Winsor & Newton) or Carbon Black (MaimeriBlu)

Scarlet Lake (W&N) or Permanent Red Light (MaimeriBlu)

Opera Rose (W&N) or Quinacridone Red (MaimeriBlu)

Cadmium Orange (W&N) or Permanent Orange (MaimeriBlu)

Lemon Yellow Deep (W&N) or Primary Yellow (MaimeriBlu)

Yellow Ochre (W&N); same name for MaimeriBlu

Permanent Sap Green (W&N) or Sap Green (MaimeriBlu)

Prussian Blue (W&N); same name for MaimeriBlu

Ultramarine Blue (W&N) or Faience Blue (MaimeriBlu)

Phthalo Turquoise (W&N) or Primary Blue Cyan (MaimeriBlu)

Cobalt Turquoise (I no longer use this color from either brand and just mix a cobalt with turquoise!)

Cobalt Blue (W&N) or Cerulean Blue (MaimeriBlu)

Ultramarine Violet (W&N) or Quinacridone Violet (MaimeriBlu)

Burnt Umber (W&N); same name for MaimeriBlu

INSIDER TIPS

1. **Set up your palette:** Squeeze pigment out of a tube into the wells in your palette and let the paint dry overnight. I like to lay out my colors in the order listed above because it mimics the color wheel and places colors that are similar in hue and often mixed together right next to each other. Also, if you follow this layout, you will keep your warm colors next to each other in the top half, and your cool colors below. I also like to follow this order in my traveler's palette (see page 11). The left mixing wells are where I mix my cool colors (blues, greens, violets) and the right mixing wells are for warm colors (reds, oranges, red-violets). This will also help you keep contrasting colors separated so you don't get muddy, brown colors in your mixing wells.

2. **Test for correct color:** Watercolor can appear much more intense straight out of the tube or even dried in your palette, so always test a color or mixture on paper, because it typically dries lighter.

3. **Eliminate separation:** Certain colors, more fugitive colors such as Opera Rose or even professional-grade colors, can be grainier than others. This can make it difficult for a color to stay mixed with other pigments. Watch out for these pigments! The trick is to keep mixing them, even on your paper, until the area of paint dries.

4. **Protect highlights:** Masking fluid (sometimes called drawing gum), is a wonderful medium that can be painted onto your paper to protect highlight areas. It's great for painting in a realistic style when you have many layers and values. You apply it to cover

the highlights and then peel it off the paper after the paint is dry. I use Pēbēo Drawing Gum or the Molotow GRAFX Masking Fluid Pump Marker. (See page 66 for more on this method.)

5 **Use gouache:** A thicker, more opaque form of watercolor paint, gouache can be used as one of the last steps in your paintings to bring highlights and details forward. You can also mix it into your watercolors to soften and thicken them. I usually have Permanent White Gouache from Winsor & Newton on hand to use when I'm painting more detailed work or when a piece calls for more opaque or pastel colors. This isn't totally necessary, but it's a fun medium to explore!

6 **Use salt:** Sea salt or even regular table salt can create a fun, web-like texture in watercolor. Just crush or sprinkle it over an area of wet paint, then let the paint dry and brush the salt off.

Paper

Watercolor paper is made specifically to absorb water well, as watercolor painting means getting your paper wet. There are three different types of watercolor paper and each yields a different result. Try all three styles to see which works best for your particular technique and approach! For all the paintings in this book, I'm using a 9-inch by 12-inch block of Saunders Waterford Coldpress paper from St. Cuthbert's Mill.

- **Hot-pressed paper (HP)** has a smooth surface. Without a toothy texture for the paint and water to hold on to, HP can be challenging for beginners, as it causes puddling and requires more control. It can work best for certain artistic styles because it can create different textures, like hard lines, when dry.

- **Cold-pressed paper (CP)** is the type of paper I always work with, specifically St. Cuthbert's Mill Saunders Waterford 140 lb (300 gsm). CP is the paper most commonly used by watercolor artists and has just the right amount of texture to allow for smooth coverage and movement, while not being so smooth that it creates puddling.

- **Rough paper** isn't pressed when it is manufactured and therefore has a *ton* of texture. This causes a lot of breaks in brushstrokes, which, for some artists, suits their style of painting or their subject.

In addition to multiple surfaces, watercolor paper also comes in a variety of thicknesses, which are measured in weight and given in either pounds per ream (lb) or grams per square meter (gsm). Watercolor paper ranges from 60 lb (120 gsm)—similar to pages in a journal or magazine—to 300 lb (600 gsm)—roughly the thickness of a paper coaster or poster board. The most common weight is 140 lb (300 gsm) paper, and that is what I use. It can withstand a good bit of water without buckling, as a lighter weight paper would, and it also allows for lifting. Using thinner paper will result in a lot of buckling and warping, and the thicker papers, which stand up to repeated wetting and washes, are just not necessary for what I like to do.

It's important to work with quality paper that meets your expectations and style as an artist, so try different types.

INSIDER TIPS

 When to stretch paper: Watercolor paper that is less than 140 lb (300 gsm) must be stretched. This process will ensure your paper doesn't warp and buckle once you add water. You can learn how to stretch paper online. However, I typically don't recommend working on paper that's less than 140 lb (300 gsm).

Choosing sheets versus pads versus blocks: Watercolor paper comes in loose sheets, pads, and blocks. A block of paper is glued down on two or more sides, with at least one corner or side left unglued. This is what I prefer to paint with because the glued edges ensure that the top sheet stays flat while you paint and prevent warping and buckling. Once the piece I'm working on is dry, I lift it off the block to work on the sheet below it. If you purchase loose sheets or a pad of paper, make sure you tape down all four sides of a single

sheet (tear out the top sheet if it's in a pad), with 3M artist's tape or washi tape. This will keep your paper from buckling once you begin painting on it.

3 **Grab a paper towel:** Have a loose paper towel on hand for color and water lifting or blotting! Good-quality watercolor paper is made to facilitate color lifting. If you're using paper such as Stonehenge Aqua CP or Fabriano CP, you can use a paper towel or dry brush to lift color off the paper while it's still wet to lighten the color or if you made a mistake.

4 **Paper must-haves:** Whichever brand, thickness, or surface of watercolor paper you buy, make sure it is 100 percent cotton and acid-free. This will help with absorbency and longevity, and the texture/fiber of the paper won't become loose when you add pigment and water to it.

Brushes and Accessories

In my opinion, your brushes are the most important piece in your watercolor toolbox. The paint you use is a close second, but the quality of brushes is crucial to the appearance and ease of painting. Brushes come in a very wide range of hair types, shapes, and sizes. I typically work with round brushes because they can execute both wide and thin strokes, which are necessary for painting animals, plants, waves, water, and more. On pieces that call for covering large areas of paper with water and pigment, I'll use a 1- or 1.5-inch flat wash brush.

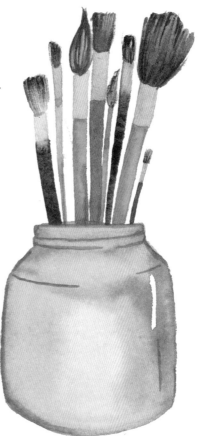

Many different types of hair are used to make watercolor brushes, ranging from Kolinsky Sable to synthetic, blends, and more. The hair of your brushes is incredibly

important when it comes to picking up color, flexibility, and durability. When working with round brushes, being able to snap or bend the hair of the brush by applying pressure to get a wide stroke, then releasing pressure for a thin stroke, is critical. Kolinsky Sable hair, which is very responsive to pressure, is therefore the most coveted and revered among watercolorists. It will last you a lifetime, but these brushes can be incredibly expensive. I've found that Princeton Synthetic Sable brushes from their Heritage 4050 series are very similar to Kolinsky Sable brushes but don't break the bank. When working with round brushes, you don't need a large range of sizes. For the pieces in this book, I use only sizes 2, 6, and 16. And because we'll be painting plenty of landscapes in this book I also love the 1-inch Mottler brush from Princeton in their AquaElite line. This brush is similar in shape to a wash brush and holds a lot of water. You'll also want to buy a cheaper brush to use with masking fluid as masking fluid can act like gluey rubber and damage your good brushes!

INSIDER TIPS

1 **Brush care:** If you take care of your brushes, you'll have them for a lifetime. After every use, make sure you wash them thoroughly. Place your palm under running water and swirl the brush around on your hand to release pigment and wash the hair of the brush completely. Make sure they are always stored flat and without the hair of the brush splayed out, so that the brush keeps its shape. You can also re-form the hair of the brush with your fingers when it is clean and slightly damp to keep the hair in place.

2 **Round brush considerations:** When buying round brushes, make sure the point is nice and clean and isn't blunt or damaged. Most brushes come with plastic covers. Hold on to these so you can travel with your brushes.

3 **Building good habits:** Avoid leaving a brush tip down in your water cup when you paint, which can bend the hairs and damage the tip of your brush.

Palettes and Water

Along with brushes, you will also need water cups and a palette. Water itself is a major ingredient when it comes to picking up pigment on your brush, mixing color, applying it, and moving color on paper. The palette I work with is called a traveler's palette. It has twelve wells for individual pigments and five larger mixing wells, and it folds up for easy traveling. I've found that these larger, foldable palettes are perfect for what I need. But you can find a variety of different size and shape palettes online. One of my favorite handmade palette companies, Sylvan Clay Works, sells beautiful moon-shaped palettes that I love!! Perfect for styling in photos!

I also suggest working with two cups of water at a time instead of just one. The reason for this is so that the pigments do not become muddy as you paint. When working with watercolor, you're using water to pick up pigment, rinse off pigment, lighten pigment, and more, so you need to make sure the water you're working with isn't too dirty or muddy. If painting with one cup of water, contrasting colors—a mix of warm and cool colors such as red and green, orange and blue, yellow and purple—will be mixed in one water cup, which isn't ideal because combining contrasting colors always makes brown. If you use two cups of water for rinsing and loading up with water—one for cool colors and the other for warm—you will never mix contrasting colors. We'll explore this more deeply in the following section on color theory.

COLOR THEORY

Understanding the basics of color theory will help improve your knowledge and ability when it comes to mixing colors, as well as help you feel comfortable and confident while you're painting. The color wheel is a helpful reference and resource when trying to understand harmonies between colors and what combinations can cause strain and disharmony or create contrast.

At right is a basic color wheel, including the three primary colors—red, blue, and yellow—which form a triad. Between the primary colors are secondary colors: purple, green, and orange. These colors are an equal-parts mixture of the primary colors on either side of them. For example, blue and yellow in equal parts make green.

On either side of these secondary colors are the tertiary colors: red-violet, blue-violet, blue-green, yellow-green, yellow-orange, and red-orange. Tertiary colors are incredibly helpful in bridging gaps of contrast between colors that sit further away from each other on the color wheel. For example, blue and red together create more tension in the painting and on the viewer's eyes than blue and blue-violet together. Adding tertiary colors to a piece that has a lot of colors that sit far away from each other on the color wheel will help the piece feel more harmonious and connected, especially when it comes to complementary, or contrasting, colors.

Complementary, or contrasting, colors are those that sit directly opposite each other on the color wheel. When we think about putting opposites together, it can either be incredible (think peanut butter and jelly) or absolutely awful (think oil and water). The same goes for complementary/contrasting colors—this is why they're called both complementary and contrasting! If red and green, for example, are used ineffectively with each other in the same piece, it can cause too much strain and competition and will force people to look away.

With contrasting colors, one color in the combination will always be warm and the other cool. If we split the color wheel in half, everything from red-violet to yellow is warm and everything from violet to

yellow-green is cool. So, if you're ever unsure about which cup of water to rinse your brush in, refer back to this color wheel.

In the following chapters, we will discover and practice how to use colors effectively so that they create harmony. We will talk about adding depth with values, and how to use hue to lead a person's eyes through your piece. Before we jump right into painting oceans, it's important that we cover the basic techniques and define terms used in watercolor.

PAINTING TECHNIQUES

All right, stop right there!

Don't you dare skip over this section on technique. DON'T DO IT! We are going to be using so much technical stuff once we start diving into oceans and beach landscapes, and you won't want to miss this practice. The first thing we need to talk about is paint consistency. After nearly a decade of teaching watercolor both in person and online, the most common question I receive is about pigment and water ratios. How much water is too much or too little? Well, it depends!

Unlike any other medium, watercolor requires the artist to think about the consistency of paint in order to achieve different results in blending, transparency, and movement. With oil or acrylic, for example, you just add paint to layer and mix in white to lighten a color. In watercolor, we're working with a transparent medium! The more water you have in the mixture, the lighter it will become, and the less water, the more intense or opaque it will be. But it doesn't stop there! The consistency of the paint will also give you much different results in value as well, so let's break it all down with a fun exercise.

THE TEA TO BUTTER CONSISTENCY EXPERIMENT

At left are five swatches of the color Prussian Blue. Each one has a different ratio of paint to water, and these five consistencies will also be used for different effects and results. So, let's break it down.

- **Tea:** The first swatch. Think about steeped tea. There's a bit of a stain of color from the tea leaves, but the consistency is very watery. If you were to spill tea on a paper towel, it would spread very quickly and leave a very light-value (or more transparent color) stain on the paper towel. When mixing up a color or combination of colors at this consistency, do a "run test" in your palette by lifting up the side of the palette to see how quickly it drips or runs. The more watery ones will drip very quickly, just as tea would.

- **Coffee:** Coffee will also drip quickly when you do the run test and will still be transparent but will have a touch more pigment in the mixture. Think of the difference between coffee and tea. You can use the same amount of water to fill a cup with coffee or tea, but the coffee is much darker and maybe even a little thicker. Tea and coffee will make up your lightest values in whatever you paint, and they are perfect for base layers, spreading over skies and water, and the base for wet-on-wet painting!

- **Milk:** Think whole milk . . . none of the skim stuff. This third consistency is thicker and less transparent. Great for our midtone values, and it still blends and disperses very quickly on wet paper but is a bit thicker. When you do the run test in your palette, this mixture should drip a bit more slowly than tea and coffee but won't just sit in your palette when it's tilted.

- **Cream:** Think thick, heavy cream. This is my all-time-favorite consistency to paint with. It's rich in color and dense, yet still spreads easily on wet paper. If I want just a little bit of a blur on the edges of my strokes, but not too much, I'll use a creamy consistency when painting wet-on-wet. If I want something to spread a lot, I'll use Tea, Coffee, or sometimes even Milk. Cream is a very dark midtone or a lighter shadow color, and with this consistency, you won't be able to notice details underneath like pencil lines or lighter colors.

- **Butter:** This is soft butter, not straight from the fridge, but closer to room temperature. Think of sticky, tacky paint on your palette or even paint straight from the tube. Get rid of most of the water from your

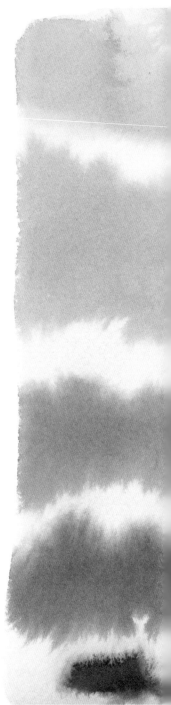

brush and slap on some paint. If you're working from paint dried on your palette, you'll need to wet the paint first to loosen it up a bit, and then you can work your brush in there to get a lot of color. Thick paint doesn't give you full coverage and there's a tackiness to it. When painting in a buttery stroke on a wet surface, this baby doesn't blend or spread much at all and is used for the darkest values and details.

At right is an example of what each consistency looks like when it's applied to a wet surface (wet-on-wet). Each stroke was painted at the same exact size to start, but, as you can see, the stroke at the bottom stayed pretty small (butter) while tea and coffee (the top two) spread quickly.

Here are three fun exercises for you to practice painting wet-on-wet, because this is where the magic happens with watercolor!

Wet-on-wet (WOW)

When water or wet pigment is used to touch another area of wet pigment or water, the technique is called *wet-on-wet (WOW)*. This is the most dominant technique I use throughout my process in both loose and realistic styles of painting and will be discussed repeatedly in this book. WOW technique can be difficult to perfect. A lot of beginning watercolorists struggle with water control: Too much water used in this technique will prevent your pigment from blending or bursting/blooming well—it just becomes stagnant. On the other hand, if you use too little water, you will see hard edges and lines and the paint won't flow on the paper. But when the right amount of water is used for WOW, magic happens! The pigment will burst and spread and create a soft, diffused edge perfect for blending, shading, creating texture, and many more effects we'll be practicing in this book. So, to practice this technique, we're going to try out three different ways to achieve WOW painting. First up, pushing!

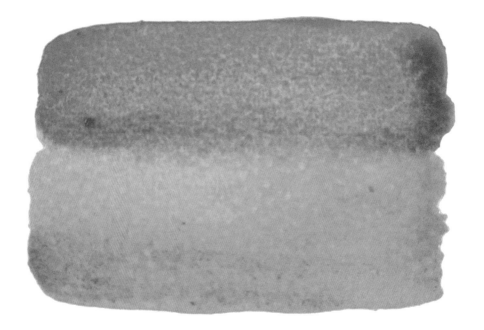

Pushing

To try the following exercise, load up your size 16 brush with water and a thick, creamy consistency of Phthalo Turquoise or Primary Blue Cyan and, holding your brush at a 35-degree angle, paint a swatch about two inches wide and one inch high. Before moving on to the next color, go back over the turquoise to make sure it's damp, or wet enough for the next steps. Rinse your brush off completely and load up with a different color. For this, I've used Lemon Yellow Deep. Start away from the turquoise and work your way toward the turquoise. Once you approach the turquoise, just barely graze the wet turquoise with the wet yellow and watch the pigment bleed! You can push more color into the other by using just water on your brush and following whichever pigment is stronger, or pushing into the other.

Pulling

This next wet-on-wet exercise is going to teach you not only about the technique itself, but also about how to achieve multiple values with one color. *Value* refers to the lightness or darkness of a color, so, when painting realistically, this is a very helpful way to use WOW painting to show gradients—such as a soft, even blend from one color to another, or depth with multiple values.

To start, load up your size 16 brush with a wet and thick amount of Prussian Blue and create a curved stroke about 2 inches wide to create the start of an outline of a circle. From here, go to your water cup and swish back and forth a few times to release some pigment and swipe the excess water off of your brush on the edge of the cup or dab it on your paper towel. Then go to the bottom edge of your stroke, and drag the same size stroke just below it, slightly touching it so that the darker stroke diffuses into the slightly lighter stroke. With watercolor, adding water to pigment makes it more transparent and, therefore, lightens it, which is what pulling does! Go back to your watercolor and apply the same steps. Continue to do this until you reach the lightest value of Prussian Blue. You should see a gradual gradient of dark blue to light blue with this exercise!

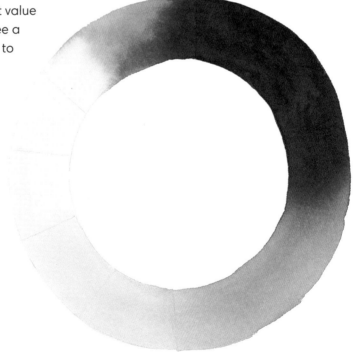

Poking

Our final WOW exercise is poking. Poking is used when you want to darken a color without hard lines or when you want to add shadows to big washes where there needs to be further detail, or even to add texture to the skin of a whale.

To practice this, load up your size 16 brush with water only, and lay down a swatch about two inches high and three inches wide. You don't want this swatch to be a puddle, so just think of adding a thin glaze of water on your paper. If you use too much water, it's going to act as a wall and block the pigment from spreading once you add it. Once you've put down your swatch, load up with a good amount of Scarlet Lake and literally poke it on the water swatch, creating red spots that burst and diffuse! Add a few of these, then switch up the color and keep poking!

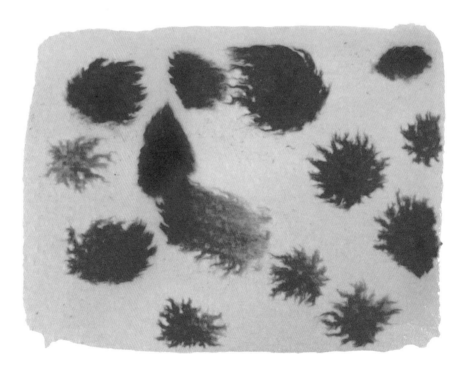

Practice all three of these exercises a couple times each to get the hang of it. WOW is best used when you want to create a soft blend between color and value, and all three of these techniques will be used quite a bit in our chapter exercises! Next, we're going to talk about wet-on-dry technique, which is used to create hard lines and detail in paintings.

Wet-on-dry (WOD)

This technique is used to create depth with layers. Simply put, wet-on-dry (WOD) is when wet paint is applied to dry paper or dry pigment. Most of the time in watercolor you will be layering from light to dark. This way we can build up color, pattern, and texture. This technique will be used more for our realistic paintings and will help us practice patience as we wait for each little layer to dry so that we can continue to build detail. Realistic-style paintings are time-consuming and require a stick-with-it mentality! It definitely takes practice. Understanding the technical stuff is incredibly important when it comes to this style, but it is much easier and less intimidating than it might seem. Below are a few examples of WOD technique in use.

COLOR STUDIES

The primary way I mix up my colors is by dabbing my brush directly on top of the dried pigment I want to pick up. For example, if I have Prussian Blue on my brush, and I want it to be slightly more blue-green, I'll go to my yellow or green dish and grab a touch of that pigment. Yes, this will put blue on top of either the yellow or the green dish, but the beautiful thing about watercolor is that, if that stresses you out, you can add water on top and dab it up with a paper towel to remove the other pigment! The reason for mixing like this is so that you can work quickly. If you just want to move hues slightly in one direction or another, this is the fastest way. The reason you'd want to work quickly is so you can use the beautiful effects you get from WOW technique, which allows a soft blend between colors or values. Otherwise, using your mixing wells to make bigger batches of colors you know you'll need for a particular piece is always a good idea. When I'm painting from a reference photo or live subject, I'll usually do this before I start painting because a lot of decisions have to happen while pigment is still wet with watercolor. If you're mixing up a specific color quickly and don't get it quite right, it can ruin your entire piece if you don't work quickly.

One thing I recommend doing before we start painting ocean scenes together is creating a color study. You needn't use your entire color list for this; this is just an eye-opening exercise that will help you create a reference guide for color. It will also help you in terms of theory and understanding hues and undertones better and help you build confidence when you begin mixing particular hues.

Although doing color studies is a great way to explore shifting the hue of a mixture, I also must point out that understanding how much of a certain color to put into a mix comes with practice and training your eye for color. For example, take a look at the chart opposite. I've combined every single one of the colors I have in my palette in equal parts, which only shows me *one* shade I can get from these combinations, while the ratios and combinations can be endless! For example, blue and yellow mixed together make green, right? But changing the ratio, or amount of blue and yellow, will give me completely different results, ranging from a deep blue-green to a neon, chartreuse yellow-green.

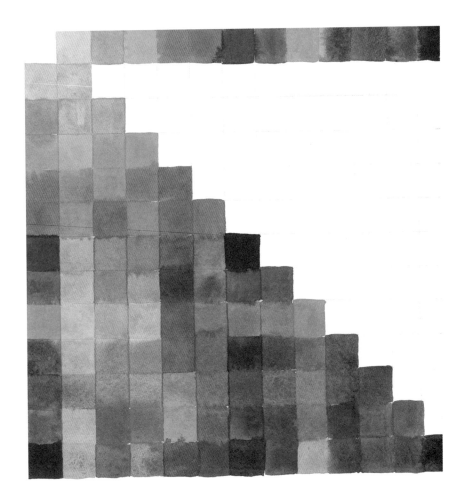

Colors from top to bottom and left to right: Primary Yellow, Yellow Ochre, Permanent Orange, Quinacridone Red, Permanent Red Light, Prussian Blue, Cerulean Blue, Phthalo Turquoise, Sap Green, Ultramarine Violet, Burnt Umber, Carbon Black

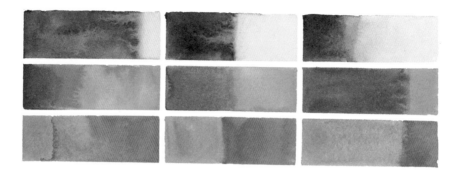

If a color combination interests you or is something you've never explored before, study it and experiment with it! For example, when I made the mixing chart above, the mixtures from Opera Rose + Sap Green and Opera Rose + Burnt Umber really caught my eye and I wanted to see what other shades would come about from different ratios of these pigments. Try out four or five or more different ratios and combinations to see what else you find!

Now that we've covered all the technical stuff, let's dive into the fun part—painting! If you're familiar with any of my other books in the Everyday Watercolor series, then you'll know I am a big fan of breaking subjects down into basic shapes. If you're not a confident sketcher or have trouble sketching and painting something from scratch, breaking your subject down into basic shapes is going to be the best thing for you.

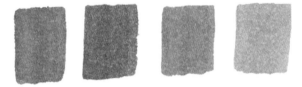

In this book, similar to my other books, we'll be tackling the most essential techniques using the medium of watercolor, while also studying each subject as shapes first so you can understand how to draw or paint anything using this approach. We're going to start with seashells and build up some confidence around sketching and painting. Each chapter that follows will build on the previous one as we move on to increasingly complex subjects. Seashells are the perfect place to start. So, are you ready?

Chapter One

SEASHELLS

Seashells are like the jewels and treasure of the ocean and the subject that I want to make sure we study first. There are so many unique shapes and patterns out there to dive into, but in this chapter we're going to explore this subject from the perspective of more basic shapes first, so we can dig in deeper with each chapter and subject from this starting point. This will also be a great place to come back to if you need something a bit more simple or loose to transport you right to that sunny beach vacation.

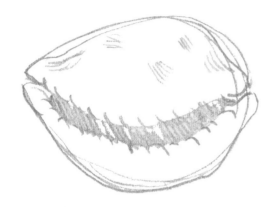

COWRIE SHELL
Oval Shape

I love this type of shell so much that I have earrings made out of them! The patterns you see on this shell are unique and often cheetah-like. Cheetah spots are so much fun to paint using wet-on-wet technique. Before we dive in, I want you to look at a reference photo of one of these shells online. What shapes do you see? Does it look similar to something else you've seen?

SKETCH

For me, the shapes of an almond and a raindrop come to mind. One side of the shell is a C curve, while the other side is an S curve, a perfect mix of an almond and a raindrop! You can lightly sketch this shape on your paper or just go straight to the next paragraph and start painting. Major tip, though, if you do sketch beforehand: Sketch very lightly! Watercolor is a transparent medium, so if you sketch too dark, you'll see the pencil lines.

STEP ONE

Starting with only water on your size 6 brush, fill the entire shape of the shell with just clean water, making sure not to use too much, just glazing over the entire area of the shell. Now grab a milky or creamy consistency of Burnt Umber and use the tip of your size 6 brush to poke in spots here and there around the wet base layer. With that same pigment that's still on your brush, grab a little bit of Mars Black or Carbon Black so that the hue is still brown, but a little bit darker. Add darker brown spots—just poking until it looks kind of like a cheetah-spotted shell.

You're poking in these cheetah-like spots using WOW. These spots should diffuse and soften around the edges a little bit because your base layer is wet. If they're spreading too much, you most likely have too much water on your brush, whereas if they're not spreading at all, your base layer is either dry or you have way too much water on your paper. When you use too much water, it can act like a wall and block the WOW magic, so practice to find this balance!

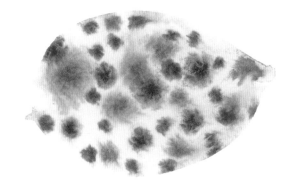

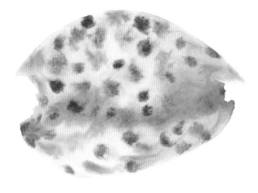

STEP TWO

While your shell is still wet, mix up a light, light wash of Cadmium Orange with a little bit of Scarlet Lake and then, with a clean brush, grab this mixture. Make sure you get just a little on your brush and then add a thin line or stripe going across the belly of the shell. These shells sometimes have this reddish-orange stripe going across the belly of the shell, but if you use too much pigment and water here, it will take over and bleed everywhere!

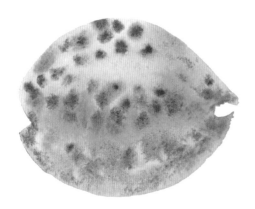

STEP THREE

With a dry brush, clean up some of the bleeding and wipe up or soak up some of the spots on the top third of the shell to leave a little shine or highlight spot.

MOON SHELL
Circle Shape

If you've never seen a moon shell before, you *must* look up photos of this beauty. It's iridescent like the moon! To capture this quality without the use of metallic paints, we're going to use a combination of neutrals, tans, and some deep blues. Before we get started, just as you did for the cowrie, I want you to look at photos of moon shells online and call out the shapes you see. I see a circle with a C curve on one end to create the opening.

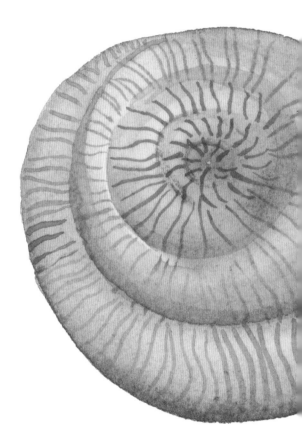

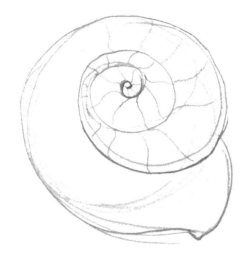

SKETCH

Inside that circular shape is a spiral. Lightly sketch the circle shape and the spiral, then refine your drawing by creating the contour of the shell; erase the basic shape sketch before you start painting.

STEP ONE

For the first layer of the moon shell, grab a lot of water on your size 6 brush and a touch of Lemon Yellow Deep and Yellow Ochre to paint a light off-white base layer over the entire area of your sketch. Once this light tan color is laid down on the entire shell, grab a tiny bit of Prussian Blue in a tea or coffee consistency and poke it into the middle of the spiral of the shell. Make sure you move quickly so that your base layer is still wet when you apply this color; that way it can spread and blend.

Once the first layer dries, you're going to show the spiral on the shell with a slightly darker tan mixture on your brush.

STEP TWO

Now you'll add some midtones, starting with a slightly darker Burnt Umber and Mars Black mixture. You want to start light just to see how it looks on the paper. Using your size 2 brush, start in the center of that bluish area, where the spiral is tightest, and follow that seam, swirling around. Now wash out your brush and, using only water, touch your brush to the line you just painted to soften it so that it blends it into the rest of the shell, without completely losing the line. While the swirl is still wet, go back over it, darkening those lines just a little bit to emphasize the shell's curve.

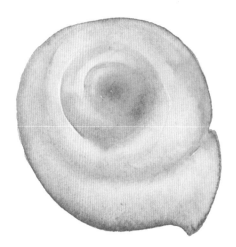

STEP THREE

Wait for the previous layer to dry and then, for the third layer of your moon shell, grab your size 2 brush and mix Yellow Ochre with a touch of Burnt Umber. Add some stripes to the shell using little to no pressure and holding your brush vertically so only the tip comes in contact with the paper. These stripes should all point back toward the center of the shell.

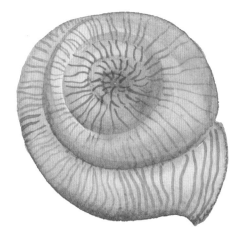

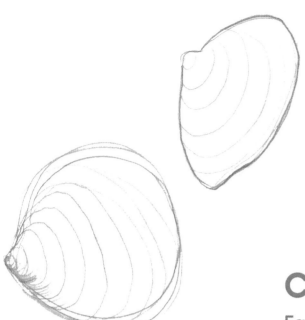

CLAMSHELL

Fan Shape

Clamshells litter the beaches near my house. My son loves collecting them and turning them over to see all the unique colors on the inside and outside of the shell. The basic shape of this shell is an oval that comes to a *V* at the hinge. If you look closely at these shells, you'll notice ridges or lines that run horizontally along them.

STEP ONE

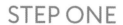

For the first layer of the clam, start with the same mixture as the previous shells: light Yellow Ochre, Lemon Yellow Deep, and Burnt Umber. Start at the outer edge of the clamshell—the wider edge—with lighter color. As you work your way toward the *V*, add more Yellow Ochre and Burnt Umber using WOW.

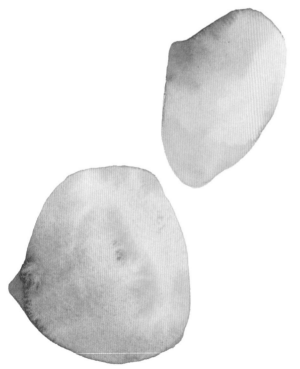

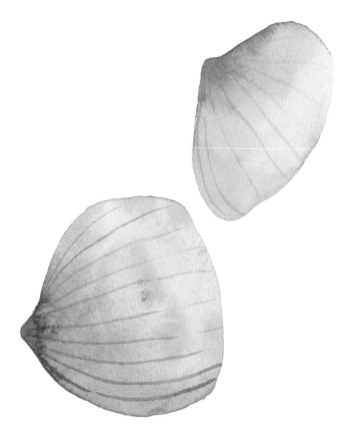

STEP TWO

For the second layer of the clamshell, mix up a dark Burnt Umber with some Mars Black and use your smallest brush—a size 2—to pull out the ridges of the clamshell. Start at the base of the shell and add these dark thin lines with little to no pressure on the brush. You can paint in these details going vertically or horizontally, like the sketch, whichever you prefer!

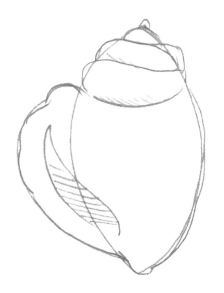

CONCH SHELL
Spiral Shape

Can you hear the ocean? Oh, that's just the conch shell up against my ear. Bad joke. No, but for real, these shells are so cool. The pinkish color inside and the spikes and spots and variety of patterns that you can see in these are so fun! If you're looking for inspiration, check out conch shells and a similar species, Murex shells. Keep in mind before you sketch this shell that it's all basic shapes to start. Take it one step at a time.

SKETCH

What basic shapes do you see? The body of the shell is a circular shape that's met with a triangle on top. Sketch in these shapes, then follow the sketch at left for the contour of the shell.

STEP ONE

For the first layer of this shell, you'll be doing the same base wash as for the other shells—Yellow Ochre, Lemon Yellow Deep, and Burnt Umber—using a size 6 brush. Avoid the opening, or mouth, of the shell where you'll be putting a darker peachy or clay color later. Cover the whole shell with this light yellowy brown wash and then, while it's still wet, grab some Burnt Umber and poke in some spots, following the shell's curves.

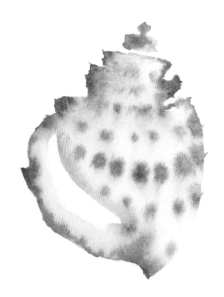

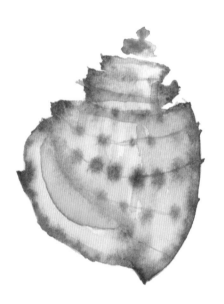

STEP TWO

While that's drying, mix up a pale peach color for the opening in the shell using Yellow Ochre, Opera Rose, and lots of water. Play with ratios in this mixture to get the right peachy color, then lay down this color in that opening and wait for it to dry completely before applying the next layer.

STEP THREE

For the last layer of the conch shell, mix a slightly darker brown using Burnt Umber and Carbon or Mars Black for adding details. Add a shadow to edge of the shell—make sure the peach area is dry first! Now add shadow to the ridges and darken the areas that would be further away from the sun or not getting direct sunlight and would be in shadow. Add a little more Mars Black to your brown for the final details. Use your size 2 brush to add dots to show the texture of the shell and to accentuate the edges and ridges.

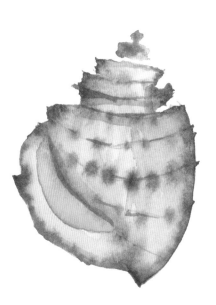

Chapter Two

PLANTS AND FISHES

Before diving into this chapter, I want you to take a deep breath and acknowledge that progress is better than perfection, right? Some of the shapes and subjects we'll be learning in this chapter might challenge your current skill level, but we're going to ease into this section with monochromatic coral and seahorse paintings and then continue to build on these techniques and shapes as we progress through each subject and combine them with some more complex shapes.

ELKHORN CORAL

WOW/Monochrome

The Elkhorn coral is just one step. Before we dive right into the painting part, let's talk about the shape and set up how we're going to approach this subject. For this painting, we're going to focus on WOW technique and working really quickly, so it's important to understand the overall shape first. Think of this coral as the roots of a tree, or as veins, even. Each main root is going to start from the same base point, with branches shooting off of those main lines to create a really intricate-looking shape, like a tree with no leaves.

STEP ONE

To get started, mix two versions of Scarlet Lake with a touch of Burnt Umber and Mars Black: First, make enough of this mix in a tea consistency to fill the whole shape. Then make a mix with the consistency of cream or milk and save it to use at the end. Using your size 6 brush, paint the entire coral with a really light wash of your Scarlet Lake mix. Don't outline the branches: Hold your brush at a 45-degree angle and press down to use the width of the brush to create the horns of the coral. Once you cover the whole area with this light wash of Scarlet Lake, go back and poke a darker version of this color using WOW to give it soft edges and a nice bleed!

STEP TWO

To finish, add a little glimpse of the ocean floor with Yellow Ochre and Burnt Umber at the base of the coral.

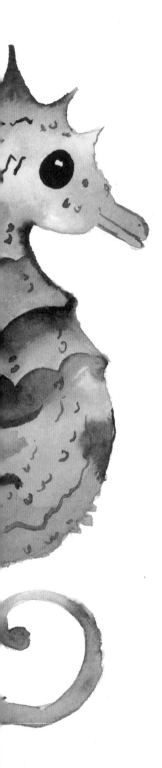

SEAHORSE
WOW/Monochrome

For this seahorse, I switched things up and used Prussian Blue and Cobalt Turquoise for my colors, instead of a tan or reddish color, which you normally see on a seahorse. But you can obviously do this with whichever color you want to! Feel free to pull up a reference photo of a seahorse to get a better grasp of more realistic colors.

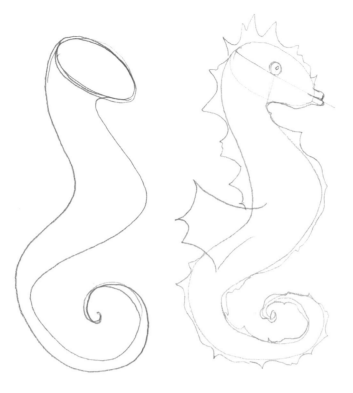

SKETCH

Start with an oval shape for the head, then sketch an *S* curve for the body of the seahorse. These shapes and curves will be your guide as you draw the contour sketch, or outline, of the seahorse very lightly. Add the mouth and spikes, carving out the shapes as best you can. Remember, sketching takes time. You won't get the perfect outline with the very first pencil mark you put down. This is why you need to sketch lightly!

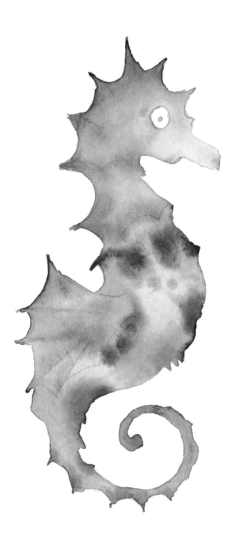

STEP ONE

Start with your size 6 brush and mix Cobalt Turquoise and Prussian Blue with a lot of water. Also prepare a smaller amount of the same mix, but with less water, to use for the darker accents.

Wash over the entire seahorse with the light blue mixture, making sure to avoid the eye area. Cover every part of the sketch—except the eye—and make sure to stay inside the lines and make the spikes pointy. As you work your way down, go over some of these edges with thicker, darker paint and a smaller brush to poke in some darker dots. Maybe outline some of the seahorse to accentuate the spikes. While this layer is still wet, add in some darker blues using Cobalt and Prussian Blue in thicker, creamy consistencies to create some interesting marks.

STEP TWO

For the second layer, use your size 2 brush and add shadow to the base of the fin area on the seahorse and any lines or ridges that you want to add dimension to. Up to now, the seahorse's fin, or wing, has just been blending in with the body of the seahorse. Grab some darker Prussian Blue and outline the edge of the fin, then rinse your brush off. Use a wet brush and pull that dark Prussian Blue down into the tail of the seahorse to blend the color. Do the same thing for each section on the tail: Add a thin dark Prussian Blue layer to outline the ridge and then pull that color down or up with water to lighten it. Repeat this with any other ridges or areas that you want to accentuate.

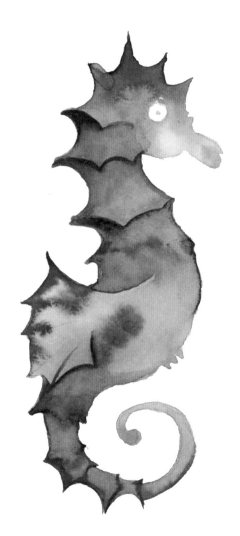

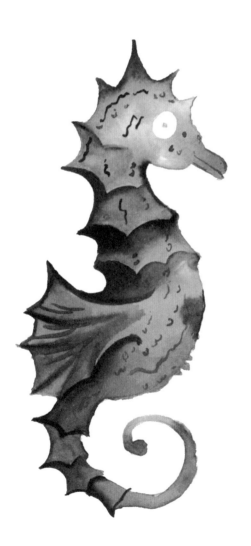

STEP THREE

For the third and final layer of our seahorse, go back in with even darker Prussian Blue. You can add black to accentuate any of the ridges on the body of the seahorse and to bring the wing even further into the foreground.

STEP FOUR

The last detail is the eye. With your size 2 brush, using Mars Black and little to no pressure, give it a black outline and then a black circle in the middle, leaving a small dot of white paper unpainted for the highlight.

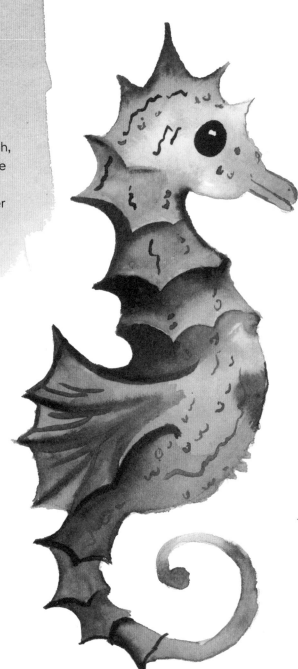

SEAGRASS

WOW and WOD

Let's keep things loose with a simple seagrass painting using both WOW and WOD! This piece will be done in two layers, but the beautiful thing about watercolor is that the first, wet layer can achieve some beautiful blending and gradients all before the first layer dries! Keep in mind, the more water you apply on your base layer, the more that puddle will act like a wall of water, blocking any pigment from blending too much. So if you want a nice bleed between a lighter value and slightly darker value, just think about glazing versus dumping water from your brush.

STEP ONE

Sometimes we can get too caught up in being exact or precise, so use this chapter as a way to practice staying loose. This will be a good practice in confidence as well! For the seagrass, we're going for a more simplified and relaxed approach to the painting, so you won't need to start with a sketch. Begin with a light layer of yellow-green—I use a mix of Sap Green and Lemon Yellow Deep—using a size 6 brush. Press down on the belly of the brush, then lift it, to make an oval shape with a pointed tip.

STEP TWO

For the second layer, grab your size 2 round brush and mix up a touch of Prussian Blue with Sap Green in a really thick mixture so it's opaque and dark. Start at the tip of each leaf and pull down a very thin line through the leaf and then down to form the stem. This seagrass is underwater so make the stems curved and flowy. And be sure all your stems meet at the base.

MOORISH IDOL FISH

Painting Separate Sections

Now, before we start with this guy, take a deep breath. You will most likely get frustrated with it, especially during the sketching phase. Rome wasn't built in a day, right? Remember to go easy on yourself and focus on developing muscle memory and taking your time with each shape and sketch. It gets easier, I promise!

SKETCH

Now it's time to get a little more complex with our technique and shapes. To start, as usual, think about the overall shape of this fish. Pull up a reference photo and start identifying the shapes. For the body of the fish, start by lightly sketching a circle. Next, split the circle in half with a light horizontal line that will act as a guide for where to paint the mouth, fin, and tail of the fish. Then add a C curve for the top fin and bottom fin, and from here you'll start sketching the contour and the fish's stripes.

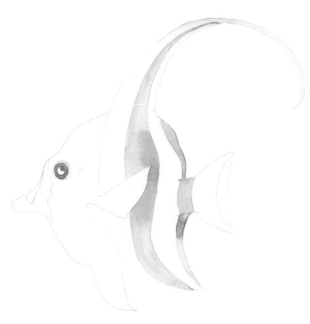

STEP ONE

Once your sketch is complete, take your size 6 brush and a light mixture of Lemon Yellow Deep. Paint in the yellow sections of the fish. Start with one section at a time and apply the first layer, or base layer, of the light yellow. Then, while that base layer is still wet, go back with a little Yellow Ochre and just darken or make some areas of each yellow section a little bit more gold, like next to the fin. This makes that fin really punch forward compared to the tail of the fish. Let this all dry before moving on.

STEP TWO

Paint the black and red sections of the fish, making sure that when you paint a section right next to the yellow, the yellow portion is dry first so it doesn't bleed. The only red section will be right on the mouth or nose of the fish. It's best to work from left to right so you don't accidentally smear the sections you've just painted. If you're left-handed, go in the opposite direction. Work your way across to the tail, making sure to avoid the areas that are to be left white.

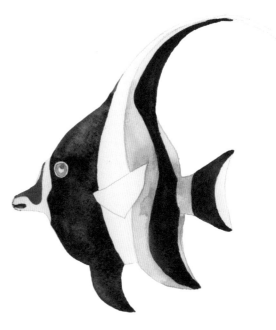

STEP THREE

Last, once the previous layers are dry, make a light blue-gray with Prussian Blue and Mars Black and a lot of water and wash it over the white areas, adding more pigment at the outer edges of the white sections to show some volume.

CLOWNFISH

WOD

"With fronds like these, who needs anemones?" *Finding Nemo,* anyone? Of course, a large portion of the population thinks of Nemo when they see a clownfish. These fish also happen to be really fun subjects to paint! We're going to practice using the paper as our white and using a combination of WOW and WOD techniques for the orange and black sections.

SKETCH

To get started, lightly sketch an oval for the body of the fish, with a smaller oval at the end for his tail. Next, sketch in three sections for his stripes. At the top and bottom of these sections you'll add a C curve for fins, with the third section being the tail at the end.

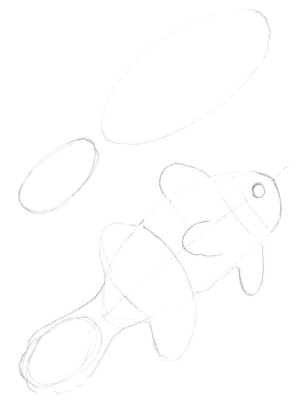

STEP ONE

Once you've finished your sketch, create a light mix of Cadmium Orange and a touch of Opera Rose so it's not bright orange. Using your size 6 brush, paint a wet layer of your Cadmium Orange mix in the sections of the body of the fish that are orange. (The fish's body alternates orange, white, orange.) For now, avoid the white stripes, the black areas, and the eye. Although, if you do get some orange into the black areas, that is totally fine because the black will be darker and cover up the orange.

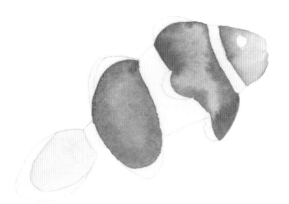

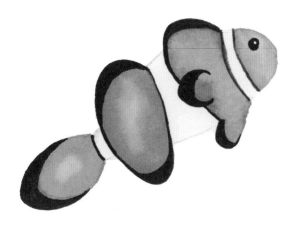

STEP TWO

Mix a darker, less watery version of that Cadmium Orange–Opera Rose color and, while your light layer is still wet, use WOW painting to add some dimension or shading to these sections by going around the edges with the darker color and letting it softly diffuse toward the middle.

When the orange sections are completely dry, use your size 2 brush for the black sections. Work left to right if you're right-handed and right to left if you're left-handed to avoid smearing wet paint. Use Mars Black—just a little bit of water and a lot of pigment—for these black areas on each fin and for the thin lines that separate the orange sections from the white sections. Use the belly of the brush for the wider sections and just the tip of the brush for the thin lines.

STEP THREE

For the fish's eye, be very careful with the tip of the size 2 brush and start by outlining a smaller circle, the inside of which will remain the white of the paper; this is the highlight. Then paint the rest of the eye black.

STEP FOUR

For the final step, mix water and a tiny, tiny bit of black to make a light gray. Paint the white sections and shade them a bit, from the top down and the bottom up. Leave your lightest area toward the middle of the fish, where they are the widest. To add dimension and to make this look more realistic, mix a darker gray, and, while the light gray wash is still wet, use it to fade from the top and bottom into the middle.

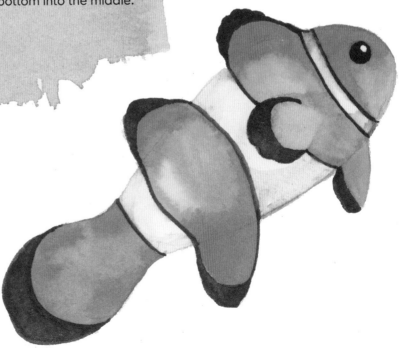

JELLYFISH

White Gouache and Splatter

This particular subject is one of my favorites to paint. I recently took my son to the local aquarium and his favorite section is the "jellies" section. We wondered at the truly alien-like nature of these creatures (they don't have any organs?!) and took in all the inspiration for this book. To create this piece, we're going to throw a lot of fun techniques into the mix to make it truly pop. From WOW and WOD to splatter and white gouache, this piece was truly so much fun to create! So, let's get started with our sketch, shall we?

SKETCH

To begin, lightly sketch an upside-down bowl. It may help you out to actually flip your paper upside down to sketch your bowl and then round off the edges or "corners" of this bowl a bit to look more like a hood. Then from there, you'll sketch in the oral arms. These arms are simply ribbon shapes with cloud-like bumps and curves. So, if you need to, start by lightly penciling in a ribbon shape for each oral arm, then add the bumps or cloud puffs to give it that fun shape! Then add some light guides for the tentacles on the jellyfish and now we're ready to paint!

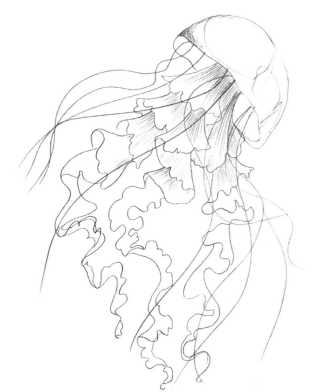

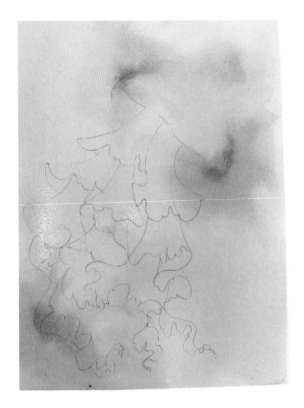

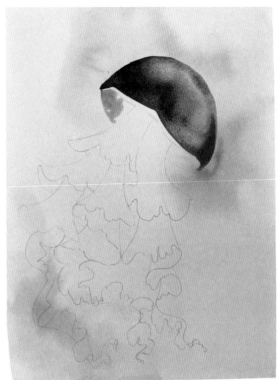

STEP ONE

Wet your entire paper, including the inside of your sketch and all around it, with clean water. I used a mottler brush for this to glaze the paper with water as quickly as possible. Next, load up a smaller brush, like a size 16 round brush, with some pigment. I chose purples and blues for my colorway, but jellyfish come in so many varieties, so pull up a reference photo if you want to explore a different color combination. For this background, we're just going to poke in lighter and more transparent colors, so think of a consistency more like tea or coffee: just a light stain of color around the jellyfish to give it a fun, bokeh-style background.

STEP TWO

Once your background has completely dried, it's time to paint in the hood, or bell, of the jellyfish. For the deep blue-violet color I used a thick consistency of Faience Blue and Quinacridone Violet from MaimeriBlu, along with some touches of Quinacridone Red for some pops of pink. Work quickly on this area so your colors bleed and blend with one another, and make sure to leave a gap of white space right at the base or front opening of the hood for some white gouache once everything has dried.

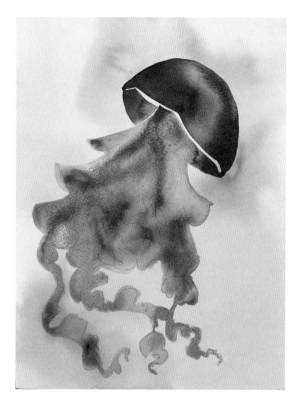

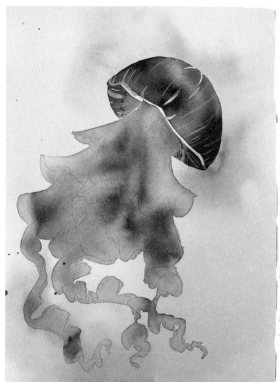

STEP THREE

Next up, let's paint in those oral arms (weird name, but this is my favorite part!). Similarly to how we painted the hood, use water to wet the entire area inside your sketch on each one of the oral arms. As you go along, start plugging in color that is slightly less pigmented than your hood. We don't want this area to get too dark or opaque because the tentacles will need to overlap and stand out, so keeping your consistency in the tea, coffee, and whole milk range of transparency will be best—again using purples to match the colorway of the bell of the jellyfish and working quickly to use WOW technique.

STEP FOUR

While the oral arms on the jelly dry, let's add some pizzazz to the hood. Using a size 2 brush, some white gouache, and a little bit of water to make the white gouache become more like a thick ink, start adding in some streaks or curves to the top. Picture these curves pointing back to the access point, or base point, of the bowl/hood. These should not be straight lines but should follow the curve of the bowl to add dimension. Do this on the inside of the hood as well but curving in the opposite direction.

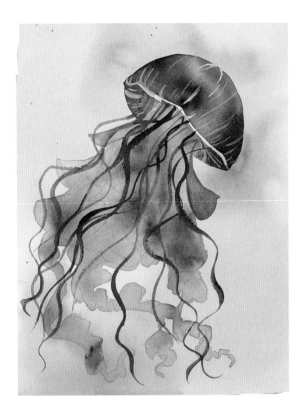

STEP FIVE

Now, the tentacles! Using your size 2 brush and a thick consistency of your darkest hue in the jellyfish—in this case it's a deep purple mixed from Faience Blue and Quinacridone Violet— paint in your tentacles! Go between medium pressure and light pressure on the brush to give it thick and thin moments to accentuate the curves and make them look more like ribbons.

STEP SIX

Last, but not least, let's add in some exciting details to the tentacles using white gouache and fun splatters with our blue-purple mixture! I've also gone into a few of the oral arms and added in a darker layer to the curves that are tucked in and underneath, again following the shape of a ribbon.

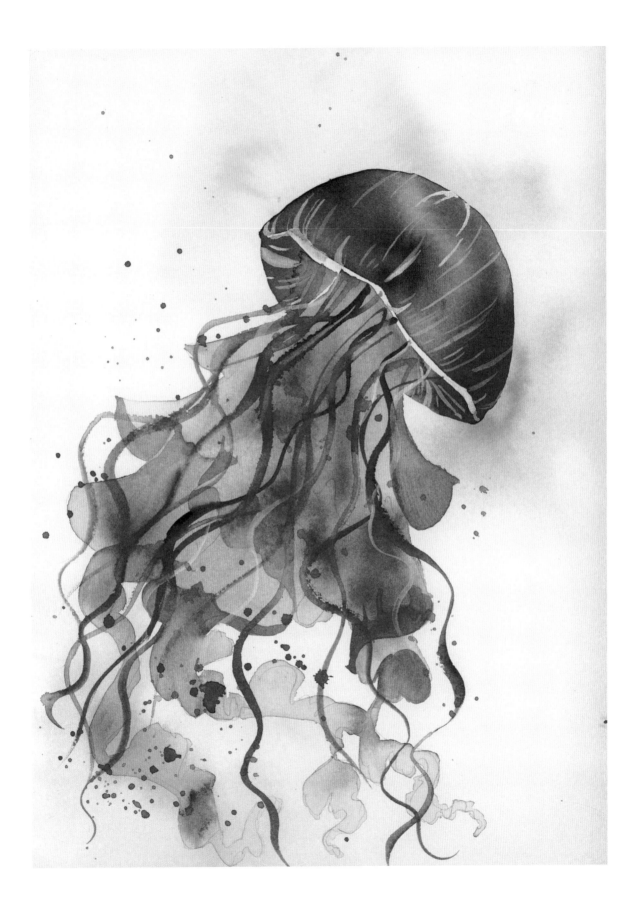

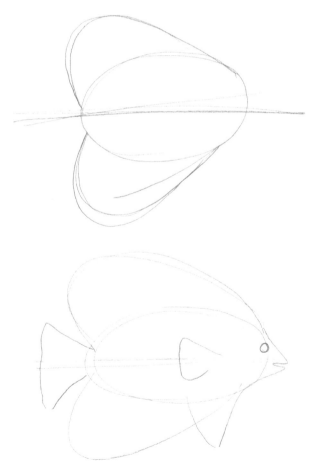

ROYAL ANGELFISH

Painting Fine Lines

This is another one where the sketch can feel a bit intimidating, but because of all the stripy goodness on this particular fish, the monochromatic pattern really helps tie it all together.

SKETCH

As you did for the Moorish Idol fish and Clownfish, sketch out the basic shapes of the Royal Angelfish, starting with a circle and a line going through it horizontally. Next, this fish has two large fins, one on the top and one on the bottom, so lightly sketch in C curves that connect to your circle. Now pencil in the contour of the fish, the smaller fin on the side, and the eyeball, using the center line as your guide.

STEP ONE

The body of our angelfish is going to be a monochromatic stripy blue. Mix Cobalt Blue and just a touch of Prussian Blue, and lighten it with some water. Using your size 6 brush, go over the fish with this light blue mixture, being sure to paint around the eye and stopping at the base of the tail. Now, while the blue paint is still wet, starting at the outside edge and painting toward the body, paint the tail yellow.

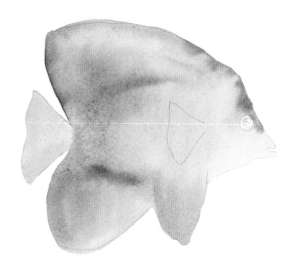

STEP TWO

When the first layer is completely dry, mix Prussian Blue with a touch of Mars Black and water in a creamy consistency. We want a color just a few shades darker than the first layer. Using your size 2 brush, paint a zebra-like pattern over the face, the body, and the fins. The face of the angelfish has its own kind of zigzag maze look to it; look at some pictures on the internet. As you get closer to the side fin on the body, the stripes point toward the tail of the fish. Start with the face and then the body, and then stripe the bigger fins on the top and bottom of the fish with a darker blue mixture. Finally, once the stripes have dried, go back and add the black to the eye and the side fin.

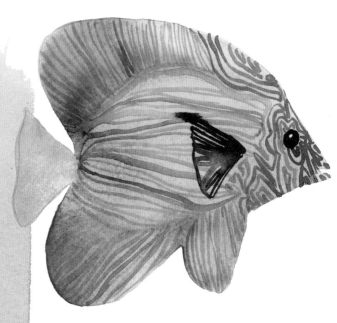

Chapter Three
SEA CREATURES

Some of my favorite ocean friends are in this section. Turtles, a jellyfish, a whale . . . all of these paintings require having lots of fun. Let's continue exploring circles, ovals, C curves, and S curves to create more ocean creatures. We'll be expanding on all the techniques we've covered thus far, but with gradually more complex subjects and shapes.

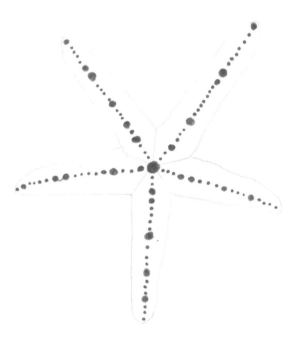

SEASTAR

Using Masking Fluid

For our next sea creature, we're keeping the sketch relatively simple. The name *seastar* tells us the shape we're going to base our sketch on. But one thing to keep in mind while you lightly sketch out your seastar is to not create a perfect star. If you look at a seastar up close, you'll see that it has bumps and texture on its surface, so sketching straight lines would look odd. Add the occasional bump. For mine, I've made sure that its arms are their widest toward the middle and taper off at the ends.

STEP ONE

For the first layer of the seastar, use a Molotow art masking liquid pump marker (I have the 2.0 millimeter point). Go down the spine of each arm with dots, starting with a dot at the center of the seastar. You can do smaller dots or bigger dots, just dot each arm of the seastar down the middle.

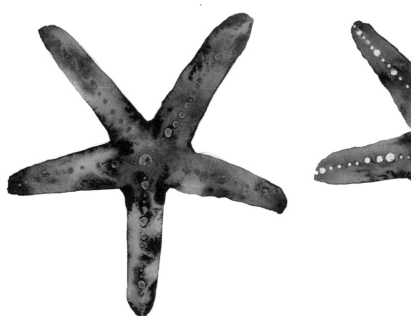
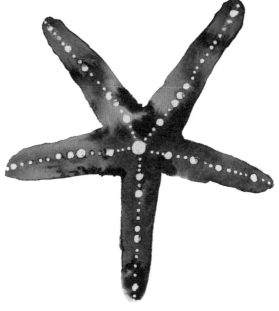

STEP TWO

Mix lots of water and a touch of
Prussian Blue. Once the masking fluid
is completely dry, use your size 6
brush to lay down a light layer of blue
all across the seastar; you can paint
right over the dry masking fluid. While
this layer of light blue is still wet, go
back in with dark Prussian Blue and,
using WOW technique, randomly dot
some darker spots on the spine and
on the edges to create a fun speckled
Shibori (a Japanese style of tie-dye)
effect.

STEP THREE

Once the blue paint has completely
dried, wrap a paper towel around
your fingernail and gently scrape
off the masking fluid. Be careful not
to smear or drag any paint around or
scratch it up. Do this very delicately
and it should come off relatively easily.

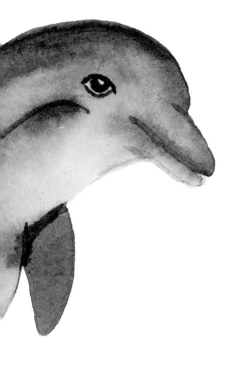

DOLPHIN
Blending Lines and Edges

I know it might not seem necessary to start with the basic shapes or curves of a subject first before sketching in the details of what you're going to paint, but trust me. Make things easier on yourself by sloooowing down and finding the basic shapes of any subject before you just whip out the sketch. With this dolphin, we're combining multiple curves and shapes within one subject, so take your time with it.

SKETCH

A dolphin may seem intimidating to sketch
at first, but everything about this subject is
just a C curve. The main shape of the body is
a C curve; the tail, pectoral fins, and dorsal
fins are all simply C curves. Lightly sketch a
long C curve to use as a guide for a dolphin
jumping out of water. You'll then place another
C curve directly below that as the underside,
or belly, of the dolphin. From here, sketch the
pectoral fins and dorsal fin, leaving space
for the face and mouth of the dolphin. Align
the dorsal fin with the pectoral fins. Begin
penciling in the contour, mouth, and tail and
a lateral line across the body of the dolphin
and erase any marks you don't need before
you start painting.

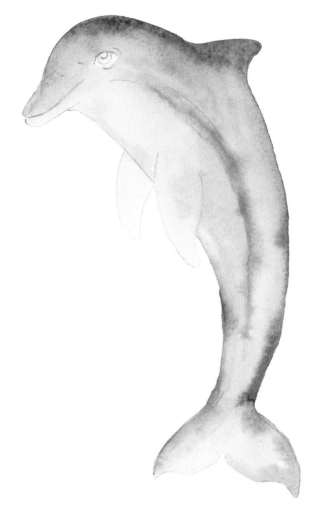

STEP ONE

Mix up Opera Rose, Cobalt Blue, and a touch of Phthalo Turquoise for a smoky blue gray. Use your size 6 brush and a lot of water to lay down a thin line on the top of the dolphin, going over the top of the nose, the head, and the fin, outlining the top first with darker color. As you get about halfway down the body of the dolphin, grab water on your size 6 brush and pull that color down so that it fades gradually into a lighter blue.

This dolphin is jumping out of the water and the sun is highlighting it. Because dolphins have really shiny, leathery skin, add darker color if needed to create more depth at the top so that it shows the gradient between darker color and lighter color. Keep pulling that color down with water into the rest of the body. Around the middle of the dolphin, add a line of darker color as well. Paint through the entire body, avoiding the eye area. Finish this step with a light wash all across the dolphin, with the darker line down the middle of the body and on the top curve of the animal, down into the fin and over the mouth, just around the eye.

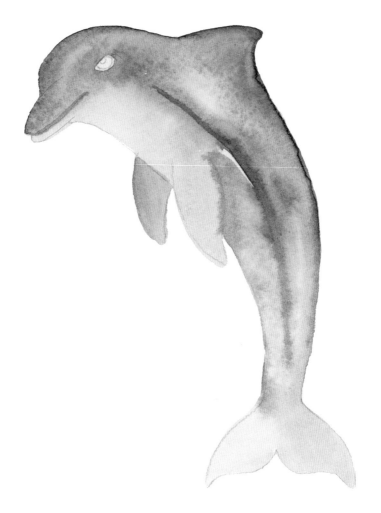

STEP TWO

For the second layer, while the first layer is
still slightly wet, drop in some Opera Rose with
your size 2 brush here and there, along the
darker lines of the dolphin. Once it's mostly
dry, add in some of your darker blue mixture
underneath the front fin and all over the back
fin so it shows some shadow. Next, while the
base layers are still a little wet, give the line a
bit more of a smooth blend and add another
thin dark line down the middle of the dolphin
to accentuate that ridge or shadow. Then add
a final thin dark line to make the mouth.

STEP THREE

Once your dolphin is totally dry, with Mars Black and your size 2 brush outline the eye with little to no pressure on your brush so that it's just two thin C curves, and then paint in the iris of the dolphin's eye, leaving a highlight toward the top middle of the eye. Add any shadow detail alongside the fins to show that one is in front and one is on the other side. You can add a splash of water around the tail of the dolphin using Phthalo Turquoise and water and rolling the brush around to create a splash.

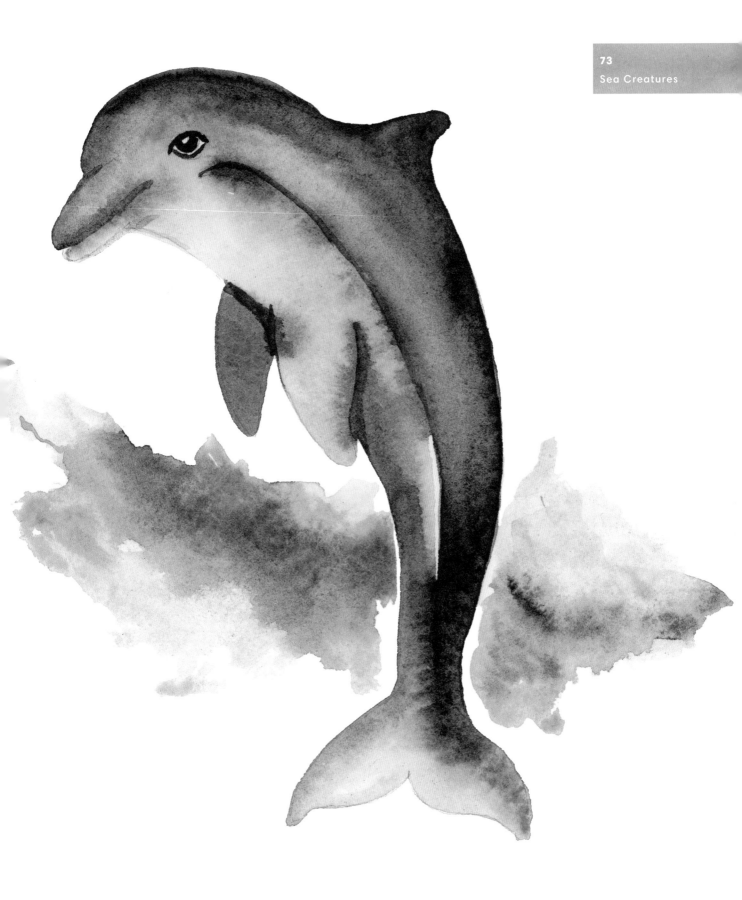

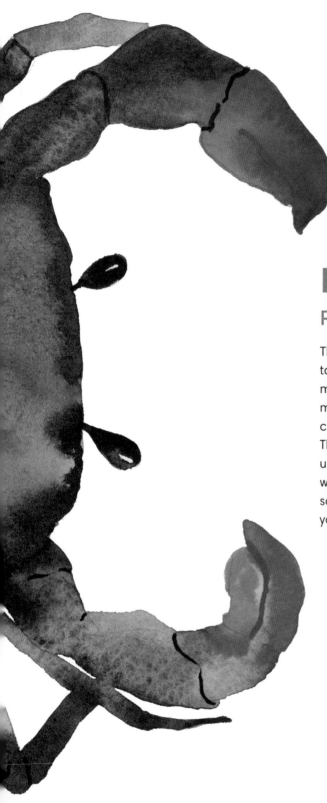

PURPLE CRAB
Poking and Blending Color

The spiders of the ocean . . . crabs! I also like to picture a crab's pincher arm like super muscular biceps, which makes them cuter to me. Just like all our other subjects in previous chapters, we're starting with basic shapes. The main goal of this painting is to get you used to WOW and using really rich, thick color when blending. This guy is meant to be vibrant, so don't be timid with the amount of paint you use!

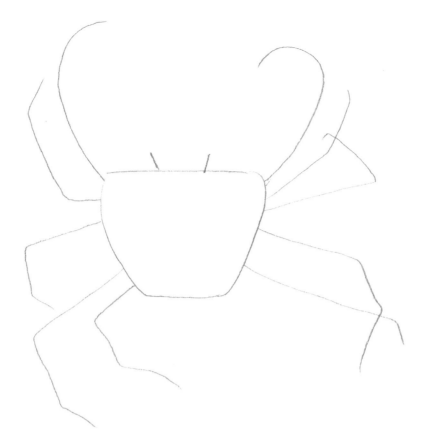

SKETCH

To sketch the crab, start with an isosceles trapezoid . . . yes, we're going back to geometry class! This will be the body of the crab. The shorter side of the trapezoid will be the back, and the longer will be the front, where the eyes will go. Next, lightly sketch in a C curve that starts from the top of the right pincer claw and goes across the crab's body to the top of the left pincer. This will be your guide for the front legs. Each leg on the crab will be directly across from the leg on the other side, so pencil in three more lines down the body of the crab as guides for the legs. Next, start sketching the contour of the crab, following your guides, adding in the eyeballs, bumps around the body, and massive claws at the top. This guy definitely lifts weights!

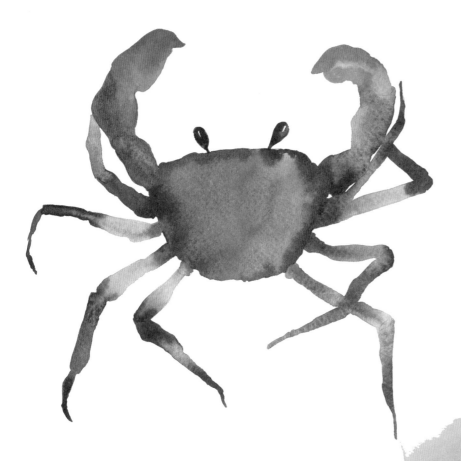

STEP ONE

Once you're done with your sketch, it's time to start painting this vibrant guy. You can paint this crab in just two layers! For the first layer, using your size 6 brush, paint a wash all over the entire body of the crab with Ultramarine Violet, Opera Rose, Ultramarine Blue, and Prussian Blue, and lots of water. Poke in color and pull color as you go to get a nice variation in your wash. As you get to the top of the claws of the crab, poke in Cadmium Orange and a touch of Scarlet Lake and let it bleed into the purples.

STEP TWO

When the base layer of your crab is dry, grab a darker mixture of Cadmium Orange and Scarlet Lake. Make sure your mixture is thicker with pigment so it's more opaque and dark, with some red. Then pull out the upper edge of the claw where it meets the bottom half of the claw to add that detail. Next, make a darker purple with Prussian Blue, Ultramarine Violet, and some Mars Black to go over the legs and eyes of the crab and add really thin darker details to show edges and connections between segments of the crab's legs.

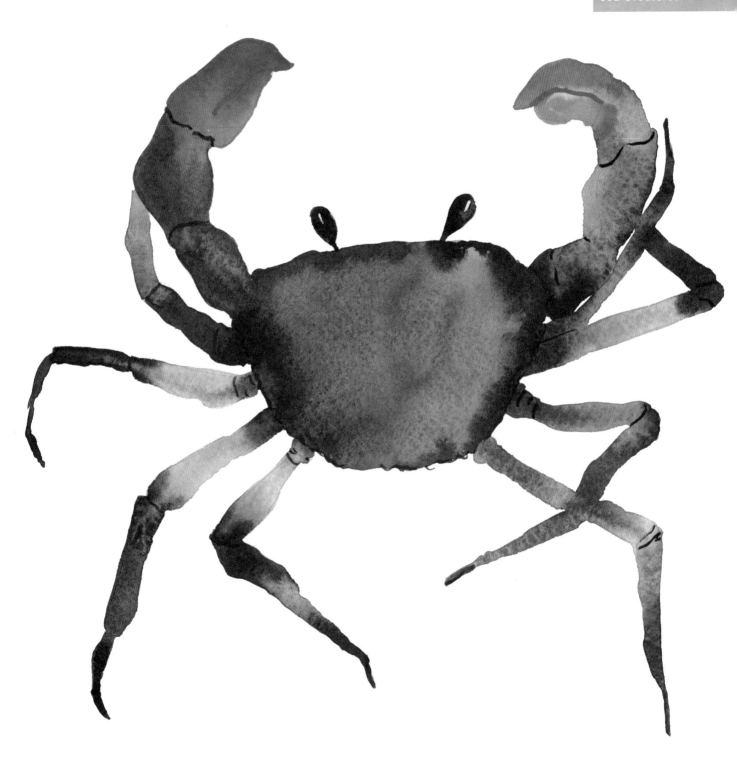

LOBSTER

The Perfect Blend of Loose and Realistic

I don't know about you, but painting in a hyperrealistic style has never been my cup of tea. I love the look from artists who have mastered this style, but I'm more drawn to a whimsical blend of loose and a couple nods to realism. This particular painting of a blue lobster is the perfect exercise and combination of the two!

SKETCH

Think of the basic shape of this creature
as a *Y*. From there, the details on the arms,
the claws, and the body of the lobster are
a variety of *C* curves, *S* curves, and straight
lines. Before jumping right into the main
sketch of your lobster, try lightly penciling the
shape of a *Y* as your guide and from there
pull out the basic shape for each section of
the lobster's body, arms, and tail!

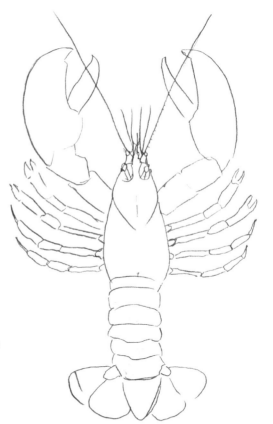

STEPS ONE THROUGH FOUR

The next four steps are going to be done using WOW technique, so you'll need to work rather quickly. Using a size 6 round brush and some milky-consistency pigments, paint in each section of the lobster except for the eyes and antennae. These will be done last, once everything is dry. Of course, when most people think of a lobster they picture a bright red crustacean, but for this guy I wanted to use some bright blues: Faince Blue, Prussian Blue, and some touches of Permanent Red Light, Quinacridone Red, and even Green Gold. The blues will be the more dominant color, so use the warm colors and the greens as just pokes of color throughout the blue to mix it up and add some shine to the hard-shelled creature.

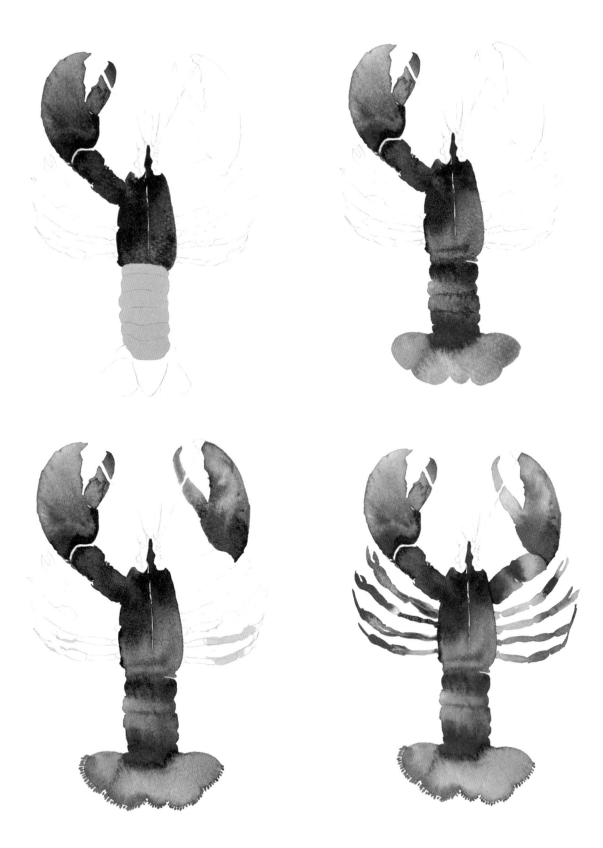

STEP FIVE

Once your base layer of juicy color is completely dry, use your smallest round brush (like a size 2) or a fine liner brush to add in some dark blue, opaque details. I mixed up Prussian Blue with a tiny bit of water to create a creamy-buttery consistency and painted small swirls, thin lines, and small dots to add texture, cracks, and bumps to the claws and body of the lobster. Then from here, it's time to paint in the last little details of the eyes and antennae. Using the same brush and pigment consistency, use Permanent Red Light to paint in the antennae and Carbon Black for the eyeballs. I left a small white gap or circle in the eyes for a little highlight. Nothing too major or realistic, but just the right touch! These last little details really help pull it all together and create a stunning lobster!

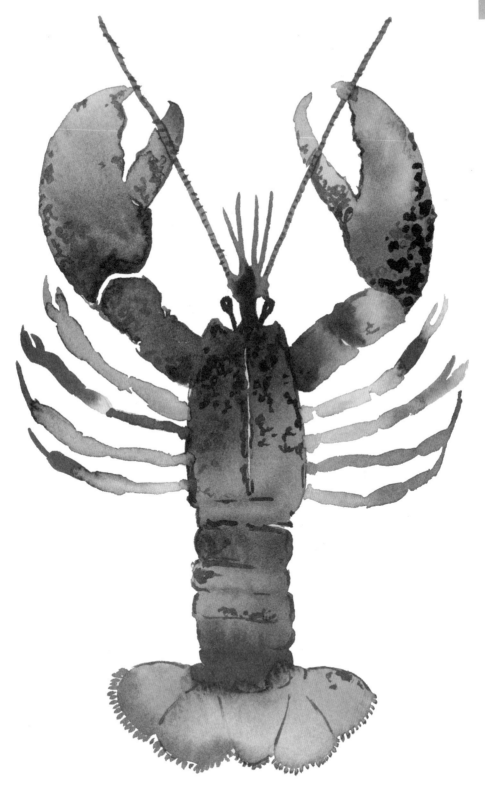

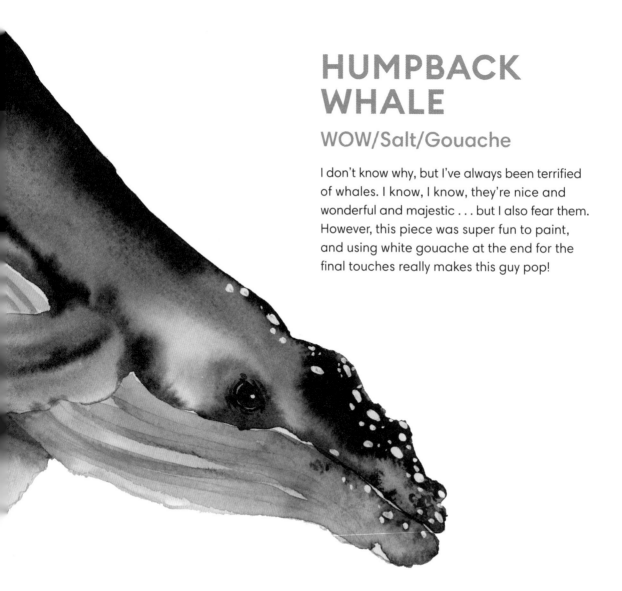

HUMPBACK WHALE

WOW/Salt/Gouache

I don't know why, but I've always been terrified of whales. I know, I know, they're nice and wonderful and majestic . . . but I also fear them. However, this piece was super fun to paint, and using white gouache at the end for the final touches really makes this guy pop!

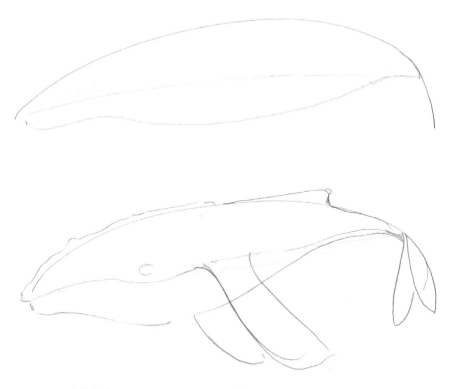

SKETCH

Just as we did when we painted the dolphin, we're going to start sketching the humpback whale with a long *C* curve. This one will be less of an arc as it's not jumping out of the water. Next, draw a straight line from the left side of the *C* curve to about an inch up from the other end. Starting at that straight line, add in a curved line that comes out around the big belly and tapers off before the end of the straight line on the right side. The tail of the whale is like two leaves. His pectoral fins are long and have both an *S* curve and a *C* curve. Once you have your guide lines drawn, start sketching the contour of the whale and adding the barnacles and bumps, the lateral ridge line, and the eye, which sits on the lateral line.

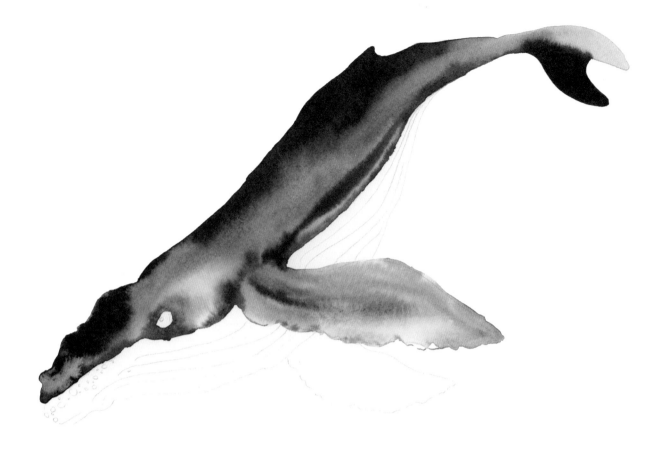

STEP ONE

Grab a decent amount of water on your size 6 brush and load up with a lot of pigment of the Prussian Blue so that you start with a really dark color. Begin on the whale's back and paint Prussian Blue along the top edge first. Then grab a lot more water on your brush and pull the edge of that pigment down into the body of the whale. As you continue to work across the top edge of the whale, continue to add lots of water. While this wash is still wet, poke Mars Black and Cobalt Blue into some areas for texture and variety. It's important to poke in the color quickly, before the wash dries, so that you don't get hard edges. Continue to add water the closer you get to the fins or the belly of the whale so that it gets lighter on the underside.

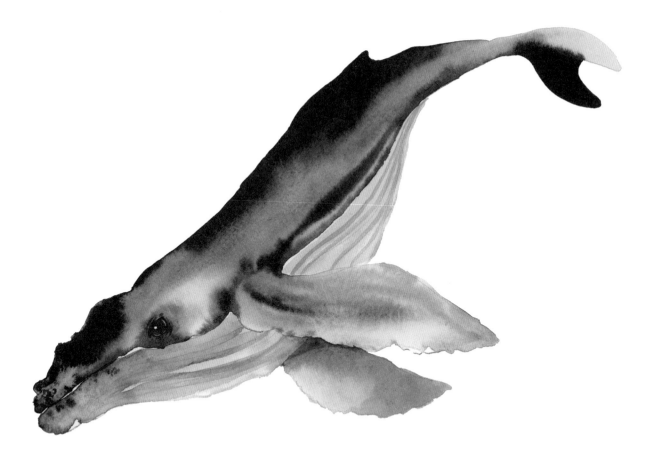

STEP TWO

Once the top layer of the whale has dried,
mix Prussian Blue and a lot of water. Apply
this wash to the bottom half of the whale. Add
some darker streaks while the base layer is
still wet so that they blend and diffuse into the
light wash.

STEP THREE

Grab your size 2 brush and load it up with some white gouache. Place little dots on the nose or the top of the mouth of the whale, varying in size and width to show that texture and the bumpiness on the whale's head.

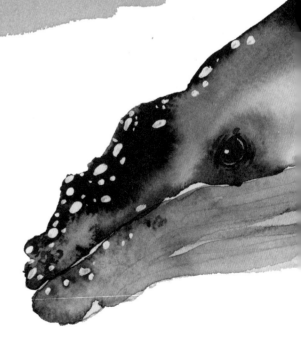

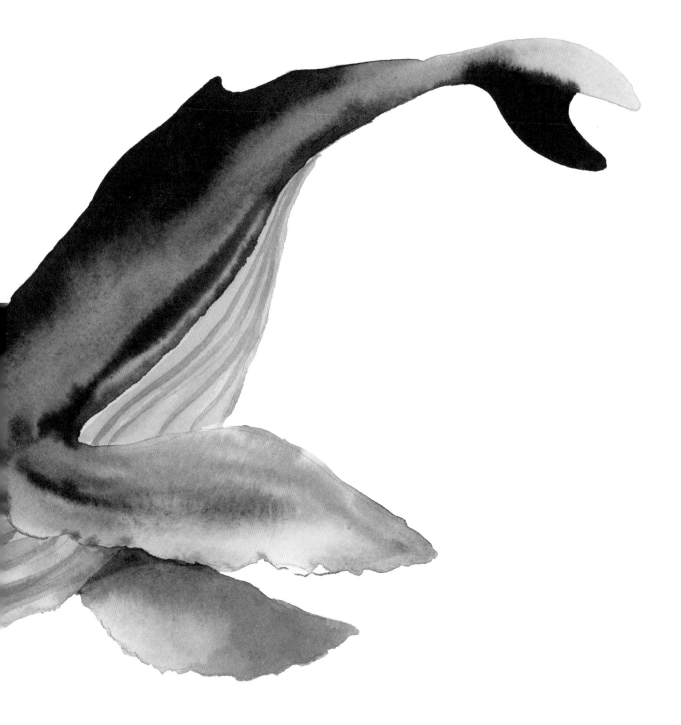

WHALE SHARK

Bokeh Background

Now that we've painted a few animal subjects and you're getting a better grasp on how to sketch these shapes, let's try our hand at creating a blurry background behind our subject! This is a fun and easy way to complete an underwater piece that features some sort of animal or fish. The key here is to use the same hues for your background layer as you would for the colors in the subject. This creates a blurry, almost eerie look to your creatures.

SKETCH

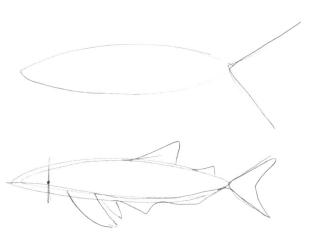

The whale shark's body is a long, narrow almond shape with a huge *V* at the end for its tail. Start sketching a long almond and your *V* shape. Add the dorsal and pectoral fins, making sure they mirror each other, by lightly penciling in a *C* curve first and then adding in the fins. This shark also has a lateral line that goes from the top of the mouth to the base of the tail. This is where the pectoral fin attaches, and the top half will have white spots and lines.

MASKING FLUID

Once you've finished your sketch, grab either a size 2 brush and drawing gum or your masking fluid marker and drop masking fluid on the top parts of the shark's body and fins in dots and lines going down the shark to create stripes and a fun dot pattern. Note: If you're using drawing gum and a brush, make sure you're using a brush you don't mind ruining as the drawing gum can be hard to get off. You can try putting a little dishwashing soap on the brush beforehand to help the masking fluid come off more easily, but I always make sure to use a specific, less expensive brush for any masking fluid. After applying the mask, try wiping off any excess, then rubbing the brush with Vaseline and letting it sit for a few minutes. Then wipe any remaining mask off and clean your brush with soap and water.

STEP ONE

Now it's time to paint! Apply a very light wash of either Cobalt Blue or Ultramarine Blue and use WOW technique. Go back near the fin and the top of the shark to add in explosions of darker blue. The bottom of a whale shark is much lighter so avoid that area of the body and just confine the color for the base layer of the shark to the top, and to show the sea behind him.

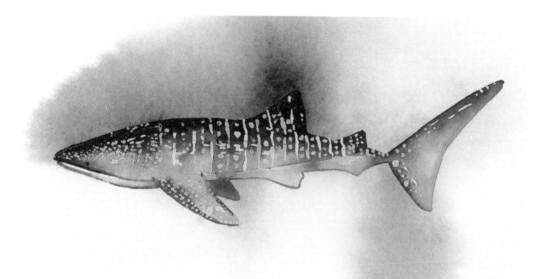

STEP TWO

Once this layer is dry, go back and add Prussian Blue and Mars Black to the top of the shark. Also lay down a very thin outline on the top ridge of his body, to separate him from the ocean. Then, using only water, pull the color into the bottom half of the shark for a dark-to-light gradient.

STEP THREE

Once that layer has dried, remove the masking fluid using your fingers, gently rubbing to loosen it and then peeling it off. Finally, go back in and darken the top edge of the shark's body. Use Mars Black to bring out the eyeball and any areas that need touching up.

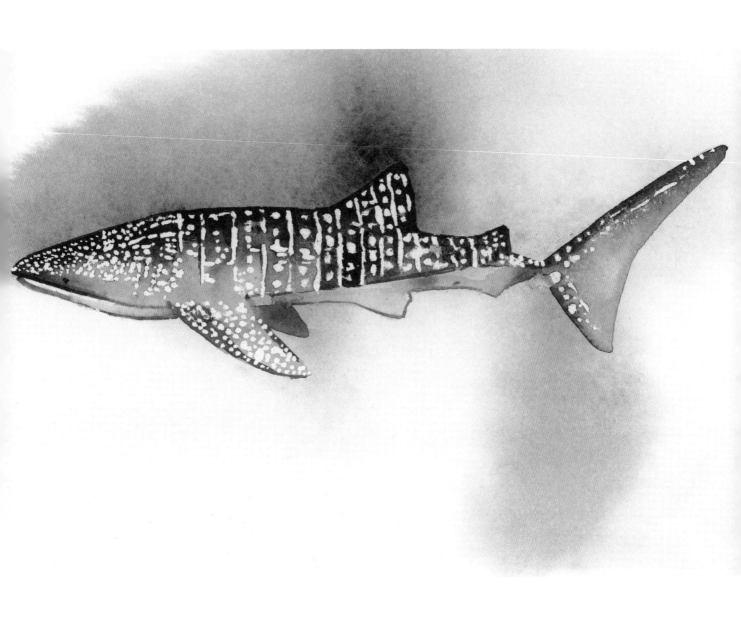

SEA TURTLE

Adding Depth

It's time to throw it all at you for this one. Masking fluid, blurry background, wet-on-wet *and* wet-on-dry! This was probably my favorite piece to paint in the entire book. The colors are fun and unique and I had such a good time creating a pattern on the shell with masking fluid!

SKETCH

Start by sketching an almond/oval shape and a *U* shape connected to the top of your oval. Add in two more longer *U* shapes for the back flipper and front flipper. Next, draw the contour of the turtle, the scales on his back and other bits. Start by masking around the tiles, or scales, on the turtle's shell and adding some spots on the flippers. Once you've masked these details, you can paint freely over them, and you'll remove the masking fluid later.

STEP ONE

With a size 2 brush and your drawing gum, paint in the area on the turtle that will define the ridges on his face, his flippers, and his shell. Use very light pressure and dance around to show dips and valleys on the turtle. And then, once the masking fluid has dried completely, apply a very light wash of Ultramarine Blue or Cobalt Blue and Phthalo Turquoise to show the sea background and also to serve as the base layer of the turtle.

STEP TWO

Once the base layer has dried, go back to some of these areas next to the masking fluid, where the white space will be, and darken it with Prussian Blue. This will add contrast and help the shadows on these curves and shells pop. Darken the area around the eye with Prussian Blue as well. With each layer, continue to darken the hues next to the masking fluid. Once this layer dries, lift off the masking fluid by gently rubbing your fingers along it, and you'll see where to darken the shadow areas even further.

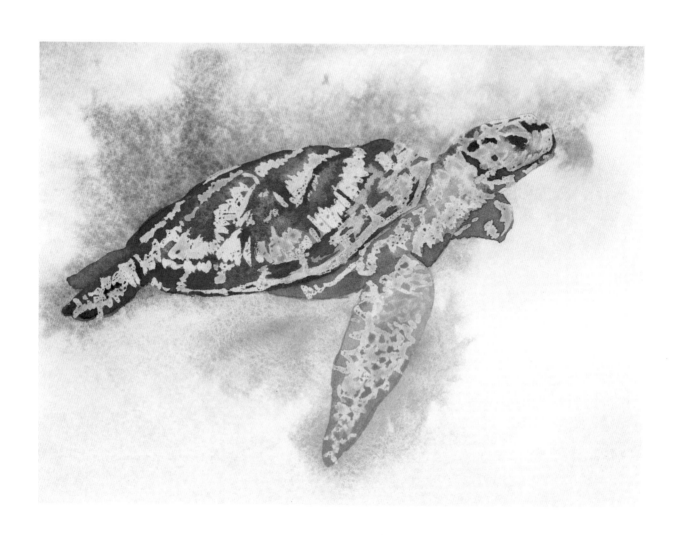

STEPS THREE AND FOUR

Finally, touch up any of the spots that need to be deepened with darker shadows, using Prussian Blue and a touch of Mars Black. Accentuate the turtle's eye and the creases of the ridges on his shell and body.

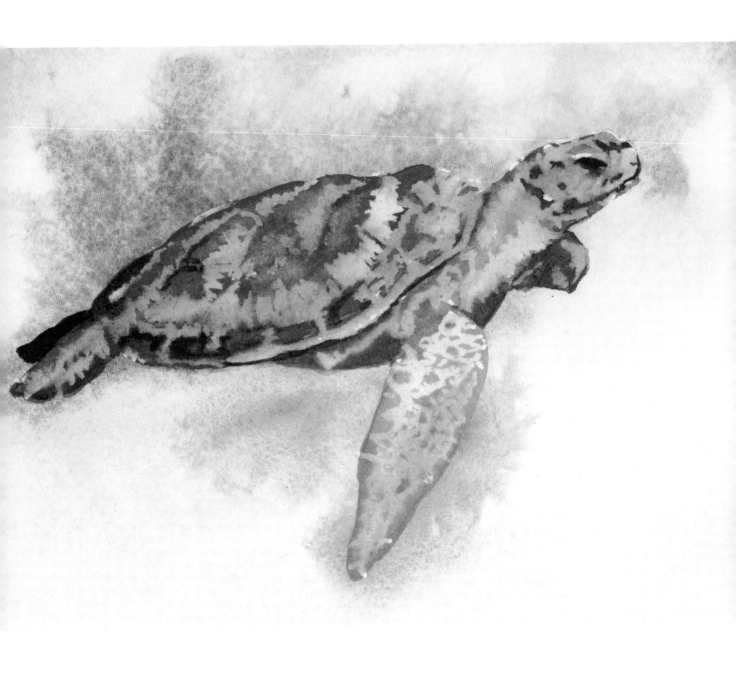

Chapter Four

OCEAN SCENES

This is where we become really familiar with all the techniques we've been covering up to this point, and then dive even deeper! Many watercolorists never fully tap into the depth and range of color that can be achieved with this medium. A lot of the paintings in the following section will help you draw out the lightness and depth of watercolor, through rendering water, light on water, and texture in water.

WATER STROKES

Creating Dimension and Depth

Painting a body of water can be intimidating, and this section will focus on studying this elusive subject. I live very close to the Pacific Ocean and take walks along the beach almost every day. It's a peaceful and very grounding place to be; the ocean is incredibly powerful and beautiful. Have you ever looked at water for a few minutes, focusing on the movement, the shadows, the shapes, and the light? It's fascinating watching different types of water surfaces: calm and clear, stormy and choppy, dark and rippled, and then pulling out the different shapes of shadows and light that hit the surface.

STEP ONE

While this subject isn't an easy one to paint, we're going to start with a very loose and simple form to get used to how the ocean flows and how your brushstrokes will flow to paint this beauty. My first tip is to practice staying loose! Grab your size 6 brush and load it up with Ultramarine Blue or Prussian Blue. Lightly zigzag across the paper. Some strokes are barely there. Some are showing the dry-brush effect (see page 160). The overall message is light and ephemeral and just staying loose. Sometimes I'll be a little bit more precise with my waves and more direct, but this gives it a really organic feel. Go back and forth over your paper with the tip of your size 6 brush, using a vertical hold. One thing to keep in mind as you're practicing this: These strokes should get thinner, closer together, and lighter in color the further in the background you go. Be sure to also leave little gaps of white space between the waves. And then, as you get closer to the foreground, you're using thicker and brighter strokes.

STEP TWO

Let's do some warming up. To begin, mix a lighter wash color (lots of water and a little pigment) of Ultramarine Blue or Prussian Blue. You want a barely-there blue and, using your size 16 brush, lay it down across the entire section of paper where you're painting water. Once you cover the entire area with your light blue wash, grab more of that same color pigment for a creamy consistency and start in your foreground with your zigzags from step 1, working your way back into the distance of the scene, using thinner, closer together, and lighter strokes. While this is still wet, you can go back over some of the ripples in the foreground to darken them. Keep your strokes very natural, just going with the flow.

STEP THREE

Now try the same steps as the previous exercise, but avoid adding ripples to the middle area of your wash. Keeping your ripples on the edges and light in the center of the wash creates the appearance of a reflection. Remember to make your foreground waves a little bit darker and fatter and everything in the background thinner and more transparent.

SURFER

WOW Pattern Study

My family and I first moved to San Clemente, a small, gritty beach town in southern California, when I was nine years old. We were all eager to learn how to surf, and that first summer of living just a few blocks up from the beach meant surfing every day. Back then, I felt like I couldn't tell anyone I didn't really like surfing because we were now part of a beach town, and I needed to fit in! But surfing is *hard* and incredibly intimidating. However, something about being out on the water and floating around, letting the current sway you, was really enticing. I gave up on surfing roughly six months after picking it up, but being out in the ocean and catching waves through body surfing is still one of my favorite things to do.

SKETCH

This piece is going to help you transport yourself into that experience and it is also great practice in creating concrete shapes with a really loose, watery background. First, lightly sketch a surfer on a surfboard in the center of your paper, starting with the pointed oval shape of the board. For the surfer, I've kept it simple, with his body forming a *V* shape. Begin by penciling in the *V* from the center of the buttocks, forming the legs, and his head placed about three-quarters of the way up the *V*.

STEPS ONE AND TWO

Next, paint in the ocean background. Using a 1-inch mottler brush or the largest flat or wash brush you have, put down clean water everywhere except for the surfer. While working very quickly, using Prussian Blue and Faience Blue, pick up some thick blue paint in a creamy or milky consistency and just poke that into the wet background. I used the point of a size 16 brush to literally poke it into the water and hopped around different parts of the ocean. Then, in between, use some turquoise, some greens—a mix of blues and yellows— and create a lovely deep ocean color that surrounds the surfer.

STEP THREE

Once the ocean background is mostly dry, grab a clean, damp, size 2 round brush to wash over the surfboard and pull in some of the blue color that's drying over the right edge of the board. Leave a gap of dry paper on the left edge of the surfboard—this step is to show a curve of the surfboard and a slight reflection of blue water on top.

STEPS FOUR AND FIVE

When everything has completely dried, paint in the hair and wetsuit on the surfer. Using a size 2 brush and a creamy mixture of Burnt Umber and Yellow Ochre, start at the base of the head with a thick line of color, then clean off your brush and, using just a little bit of water, pull that color up gradually so it fades from a dark, more concentrated brown to a light, transparent brown that reflects the light and curve on the top of his head. Then clean off your brush and do the same thing on the wetsuit, using Carbon Black in each section for the back, arms, and legs.

STEP SIX

Last, paint in a thin line of Prussian Blue on top of the surfboard for a little detail, and voilà!

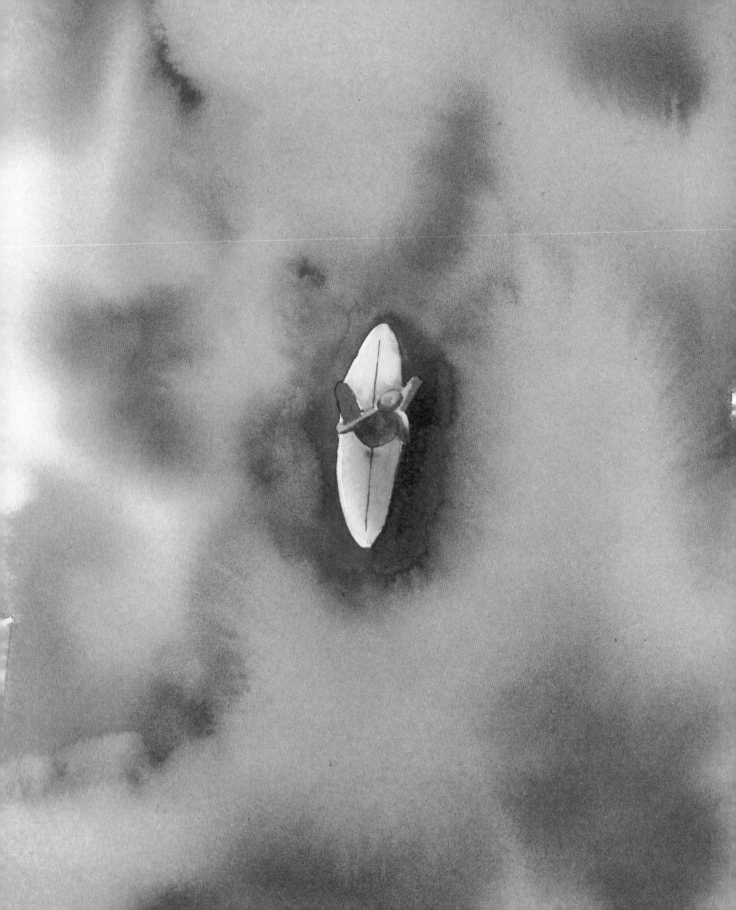

WAVE STUDY

Let's Go Deeper into Waves

This entire chapter is dedicated to a sketch study of waves. To really grasp how anything in this natural world is formed, we must first study its shape. Once you identify the oval shapes and lines on the wave, you'll truly know how to form your waves in any landscape or ocean painting. Waves are one of my all-time favorite subjects to sketch.

It's important to note where you are viewing a wave from. If it's a crashing wave from the side, you will most likely see the barrel, or the opening, of the wave. This barrel is an egg or an oval shape, with the top and bottom of the wave forming straight horizontal lines. The crash of the wave is essentially a cloud shape, while the inside of the wave will form C curves that follow the swell of the egg and slowly become flatter, and the top of the wave that meets the crash will also reflect the curve of the egg, but in the opposite direction of the inside.

SKETCH

To practice and really study this shape, take a thin piece of printer paper and form it into different wave shapes. Study where the shadow begins. If you switch up the angle of your vantage point on the wave, what do you see? The curves or details of the wave will always follow that barrel or egg shape.

Use these sketch examples as guides for the basic shape of waves, but if you're near the ocean, go study! Or if you aren't near any body of water that forms waves, study it in surf magazines, in movies, and in reference photos. It is truly fascinating to watch these shapes form, crash, and subside!

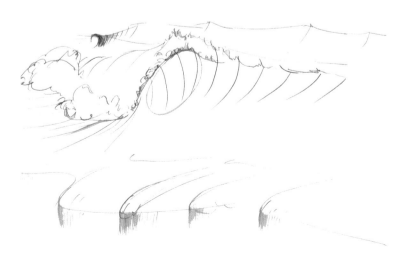

WOW WATER PATTERNS
WOW Pattern Study

The biggest challenge I see in painting waves and water is understanding where to put your shadows. To help, take a look at the sketch at left and study waves: they kind of follow a *Z* or zigzag pattern. Keep this in mind as you paint water and sweep your brush across, don't just go in straight lines back and forth, create *Z*s and zigzags!

SKETCH

Before getting started with painting the fluid patterns piece, grab a number 2 or HB pencil—something light—for a sketch study. I like to start off with rough, really light curves and wave marks in a zigzag pattern, beginning with my first diagonal line, and then going back across in the opposite direction. Draw crests and curves of waves and shapes in squiggly fluid patterns to which you'll then add shadows, midtones, and highlights using your pencil.

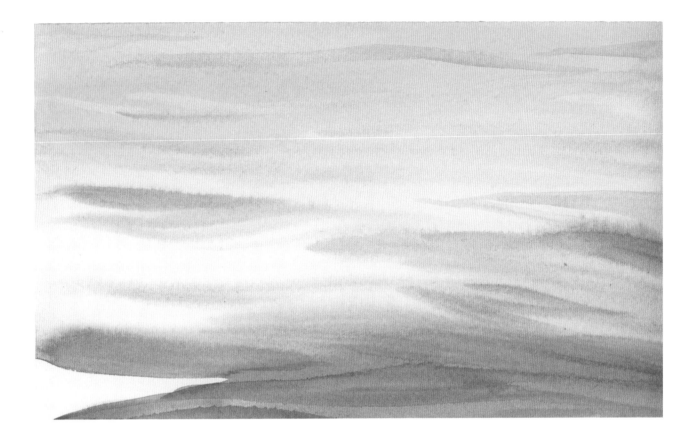

STEP ONE

Now that you have a good understanding of the shapes of these waves and where the shadows will be, it's time to lay down your first layer, a light gradient wash of Cadmium Orange and Opera Rose and lots of water, for the top section of your water scene. Lighten the color as you pass through the middle of your paper, and then add a mixture of Cobalt Blue, Burnt Umber, and a touch of Mars Black to the bottom section of the paper. It should be a gradient of a pale peachy orange to almost no color in the middle and then a cobalt smoky blue at the bottom.

STEP TWO

While your wash is still wet, use your size 16 or 6 brush (depending on how large your painting is) and paint in your wave shadow colors. For your darkest wave colors, try using a Cobalt Blue, Burnt Umber, and Mars Black mixture that's slightly darker than the base color and paint your waves using really spontaneous, back-and-forth strokes. Use pressure and release to make your waves undulate. Move your brush back and forth, finding those crests like you did in your sketch.

Make your waves thinner and lighter as you move up the paper toward the orange-peach background. Start adding your darkest color to the top edge of the waves in the foreground, making sure that they are much darker than the ones in the background, to show distance.

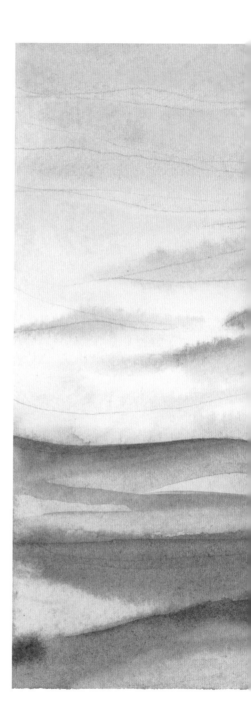

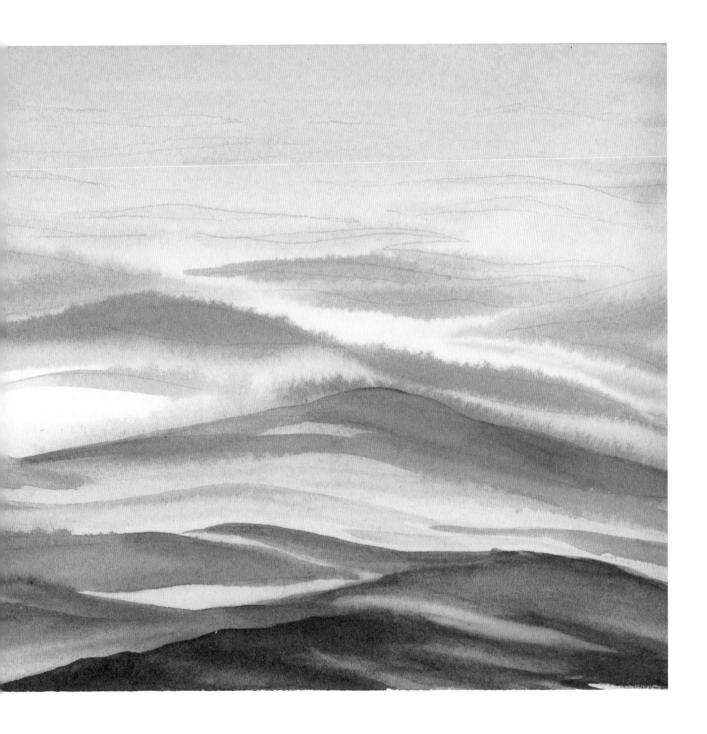

CLOSE-UP OF WATER

Using Masking Fluid to Create a Pattern

I want you to picture walking out onto a pier, leaning over the railing, and looking down at the ocean below. The sky is clear and the sun is bright, and the waves are crashing beneath you in the shallow waters. The crashing waves are creating a foamy, bubbly pattern between the turquoise and cobalt. This is one of my favorite views of the ocean!

STEP ONE

Take your masking fluid brush, dip it in
your drawing gum, and paint in the foam.
Paint randomly, sporadically, and fluidly.
Don't overthink it, and keep in mind that
you're not trying to make a specific shape
or pattern. Focus on staying loose and
letting the brush and the drawing gum do
the work of creating the foam.

STEP TWO

When the drawing gum is dry, load up your size 16 brush with lots of water and some Phthalo Turquoise and cover the entire paper with a light wash. While this is still wet, start poking in darker, thicker color, using more Phthalo Turquoise and some Cobalt Blue in the areas of the waves that are right up against the drawing gum. This will create a shadow where the foam starts and should blend into the lighter wash from your first layer.

Continue adding deeper colors to create movement on the water but keep this loose and don't cover the entire surface with these darker blues. You want to create depth with light blues and darker blues, turquoise and cobalt. Once the paint is completely dry, remove the drawing gum by gently rubbing it with your fingers to loosen it, then peeling it off.

STEP THREE

For your last step, using mostly water and a touch of Cobalt Blue, grab your size 2 brush and lightly paint a shadow edge on some of the white, foamy shapes. This will help add depth to the foam and take it from flat to three-dimensional!

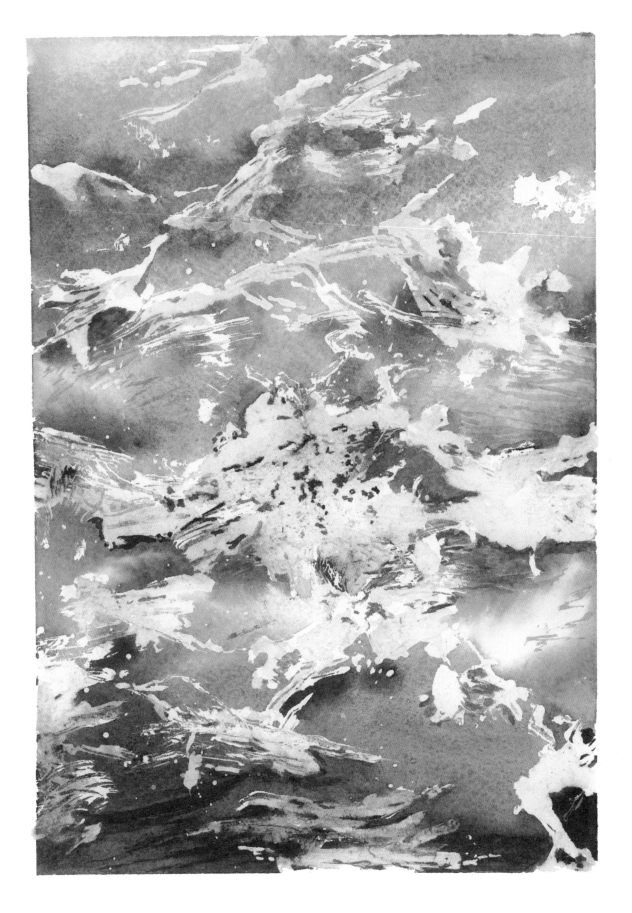

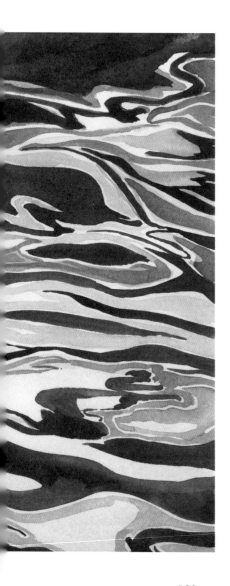

WOD FLUID PATTERNS
WOD Pattern Study

In a previous section, we focused on doing a water study using wet-on-wet painting. Now we're going to turn our attention to wet-on-dry technique to paint patterns in water. Picture glistening water. The sun is directly overhead, and the ripples on the water are creating squiggly, dark shadow patterns on the surface. This piece is full of layers and shapes and requires a lot of patience! It's probably going to look like a bunch of weird shapes at first, but it eventually comes together.

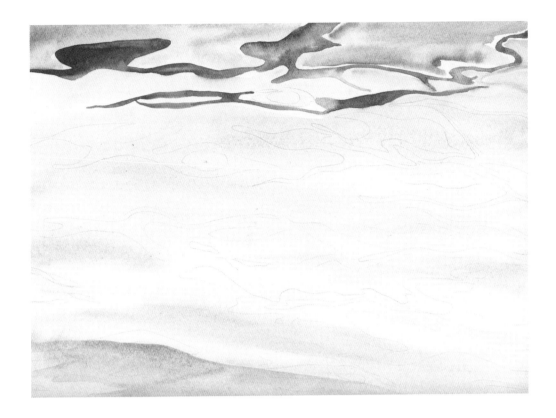

SKETCH

Lightly pencil in your shadow squiggle patterns. Keep this step light and fluid. These shapes should be thin with a wave-like movement, so structure them in zigzags across your paper as in our practice sketch on page 112. You don't want these shapes to just go straight across your paper; you want them to be angled and to break apart and create zigzags.

STEP ONE

Once your sketch is done, cover your entire sheet of paper with your lightest blue wash. It's so light that it's just a shade darker than the paper color. While this is wet, go in and around where the darkest shadows will be and start dropping in some darker, midtone blues along the edges. Leave some areas along the shadow sections bright and in your lightest color, to show highlights.

STEPS TWO
AND THREE

Once this base layer dries, use your size 6 brush to paint in some slightly darker midtone blues, squiggle shapes around the shadow squiggle shapes. These should outline where the dark shadows will be and help elongate those ripples. Then, load up with your darkest blue and fill in the shapes of your shadows on the ripples. Again, this piece takes patience, but it will really take shape as you work on it! You may want to use a reference photo of ripples and glistening light on water to help guide you through this as well. Think light to dark and patterns wiggling around the ripples in the water.

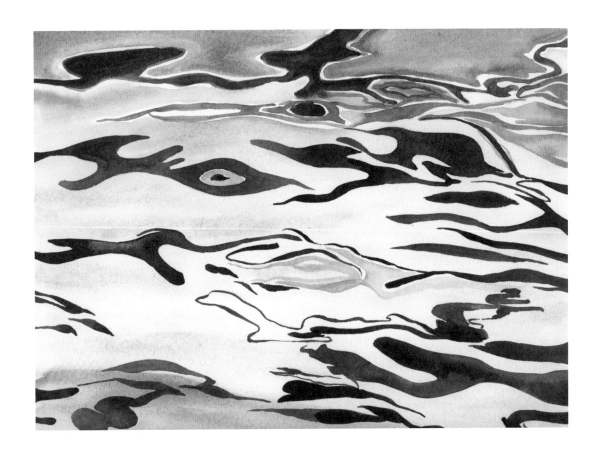
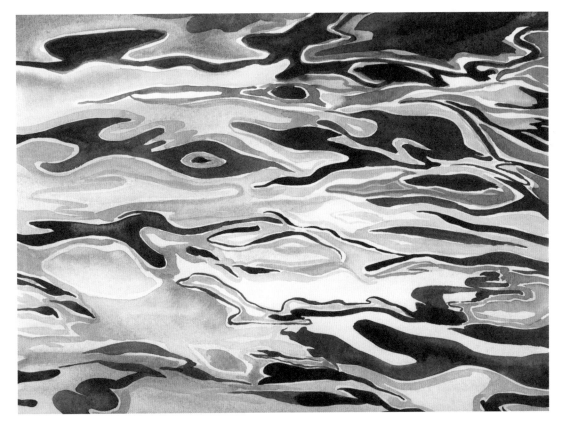

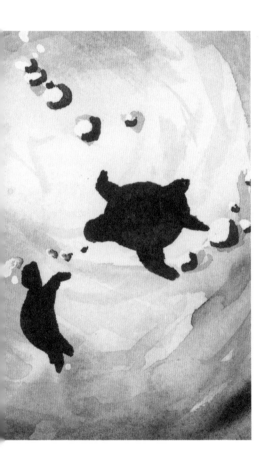

LIGHT

Light Shining Through Water

"I wanna be where the people arrrrre . . ."
Yes, I went there. Songs from *The Little Mermaid*
were stuck in my head all day after painting
this one and it's so much fun to paint. There's
no sketching in this piece, so let's jump right
into painting!

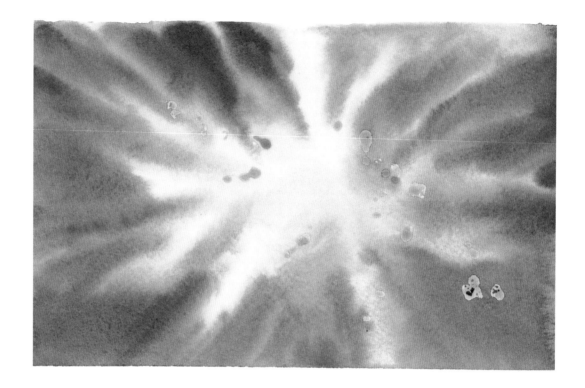

STEP ONE

First, we're going to put down some masking fluid or drawing gum in little bubble-like shapes around the paper. I kept mine mostly toward the center, where we'll eventually be painting some turtles. Next, grab a big wash brush or your size 16 round brush and water, and wet the entire sheet of paper. Now load up your brush with a thick mixture of Prussian Blue and Mars Black and paint WOW strokes that point toward the center of the paper. These strokes should vary in length and hue and value just slightly and leave a circle in the middle of the paper that is mostly untouched. This is the light shining through the water.

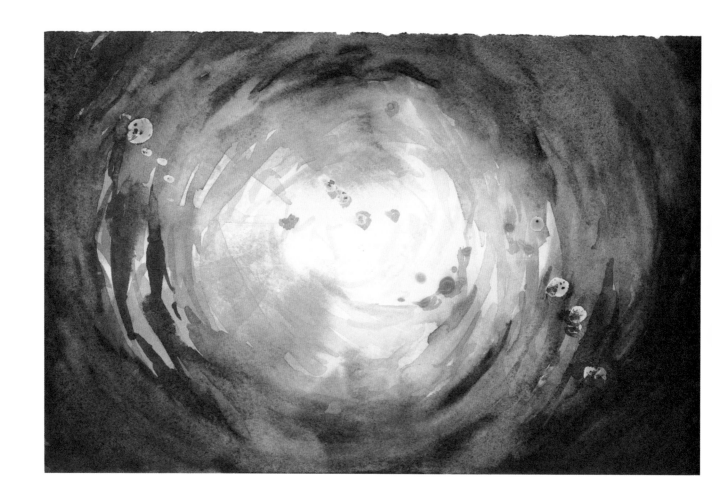

STEP TWO

Once that layer is dry, grab your size 6 brush and darken the edges and corners of the picture, creating a frame for the light at the center. Use water to pull the dark blue from the corners and soften the color as it gets closer to the center. You could even add strokes that look like waves or movement in the water at this stage as well.

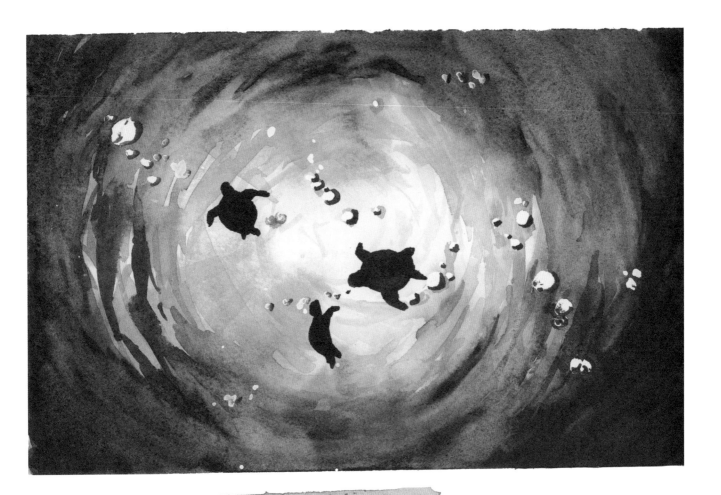

STEP THREE

Once that layer is completely dry, it's time to add the turtles! For these little creatures, we're keeping them loose and just focusing on shape, or silhouette. Use the belly of your size 6 brush and some Mars Black to paint in the turtles and to add shadows to the bubbles. When everything is totally dry, remove the masking fluid and voilà!

CRASHING WAVE

Lifting Color

In this section, we're going to study how to create foam and a crash in an ocean wave using masking fluid and an X-Acto, or craft, knife. A craft knife is a pointed blade mounted on a pen-like body and is great for scraping off little bits of paint to create flecks of light in the water.

SKETCH

Lay down a very light and simple sketch with an HB or a number 2 pencil (something that can sketch super lightly). Draw a very straight horizon line in the background, about two thirds of the way up from the bottom of your painting.

Then sketch in a light line at a 35- to 45-degree angle, starting at the left side of your page and going up to just below the horizon line. This will be the crest of your wave. Outline a cloud shape around the top of that wave for the foam, and then lightly sketch in some rocks and cliff walls that this wave is crashing into.

STEP ONE

Use masking fluid or drawing gum in the areas that you want to keep white: the crest of the wave and around the edges of the foam where the wave breaks on the rocks (no need to fill in the whole shape; just be careful not to paint into it). Once this masking fluid dries completely, lay down a wash of really pale Cobalt Blue across the sky and the sea, avoiding the rocks and being sure not to paint into the foam area. Make sure your sky and your water closer to the horizon are lighter. As you get closer to the foreground, start to drop in a darker mixture of the Cobalt Blue and Ultramarine Blue. You can also use Cobalt Blue and Prussian Blue if you don't have Ultramarine Blue. Painting over the rocks is also okay because this is just a light layer right now. The rocks are going to be more opaque and much darker. Because there's masking fluid on the crest of the wave, we can paint right over it, making sure to avoid the big white area in the middle of the foam— the big crash. Gradually add more of the Cobalt Blue and Ultramarine Blue mixture as you work your way down the paper.

STEP TWO

While that first layer is still wet, use WOW technique and drop in some Phthalo Turquoise and Cobalt Turquoise here and there and under the crest of the wave next to the crash. Drop in darker Cobalt Blue and Ultramarine Blue strokes for ripples in the water in front of the wave, just like we did in the previous chapter. At this stage, everything so far has been done quickly and freely. Try not to overthink how the shape of the wave should be shaded.

Once this is completely dry, remove the masking fluid, very delicately and carefully. I use the eraser end of a pencil or my fingertip to gently loosen it.

Next, using your size 2 brush, start to pull midtones and darker details into the foam where it crashes on the rocks. Paint the rocks in a light mix of Burnt Umber and Mars Black; you'll go back in the next step and add in darker details to the rocks and in the waves and water. Make everything just slightly darker than your first layer. As you get closer to the crash wave, scrub your brush around for a dry-brush effect. You'll scrape off some of these details later at the very end for more water droplets, but just add in details where the rock is going to be around the wave, followed by the darker details on the wave itself.

STEP THREE

Now, with a size 2 brush and using a thicker, creamy mixture of Cobalt Blue, Phthalo Turquoise, and some Prussian Blue, add some darker ripples to the water in the foreground and in the background, keeping in mind that as you get closer to the horizon that your ripples should get fainter, smaller, and thinner, just like we practiced in previous paintings. Add some shadow detail using darker color under the crest of the wave just beneath the crash. For every section where you add darker color under the white foam of the wave, grab a clean paper towel and just lift some of that wet paint, very faintly, to create the look of mist or spraying water. Do the same thing with the rock: Add a darker brown mixture on top of the rock, and use a clean paper towel to lightly blot it up to create a spray effect. You should be pulling faint bits of pigment up with your paper towel.

Next, use your size 6 brush and with clean water wet the bottom of the foam to about halfway up the crash of the wave. Then mix up Ultramarine Violet with a touch of Burnt Umber and just drop that in to create a shadow on the wave.

Continue to add detail, darker zigzags, and ripples in the wave. Under the wave where it's starting to form and crest, bring really thin straight lines down to show movement in the wave with a darker blue mixture and some turquoise, keeping these strokes really faint, really sparse, and thin. Then mix up Burnt Umber, Cadmium Orange, some Ultramarine Violet, and some Mars Black. Paint in a pale cliff in the distance. And, as you go behind the wave, make sure to grab a clean paper towel and pull some of that color into the crash of the wave to continue creating that spray effect. Add some shadow or reflection in the water beneath the rocks, using that same brown mixture and your size 2 brush and faintly pulling down some zigzags, which should grow thinner and smaller as you move away from the rock.

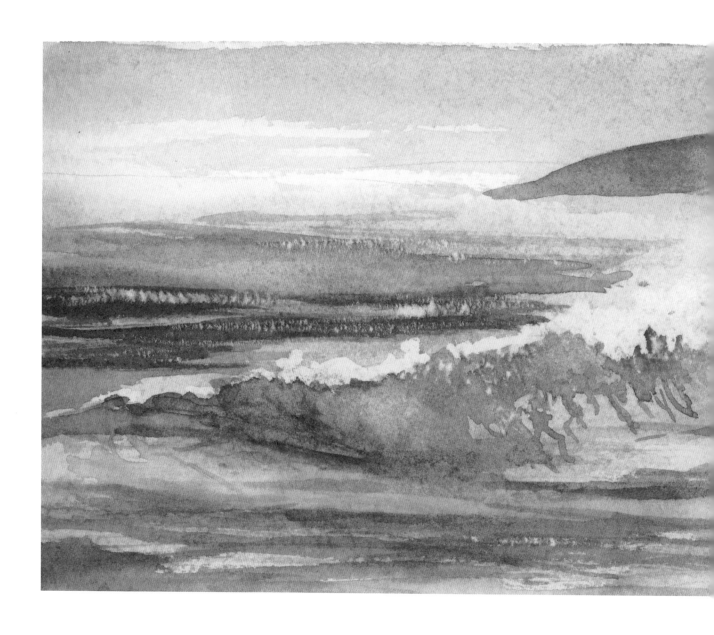

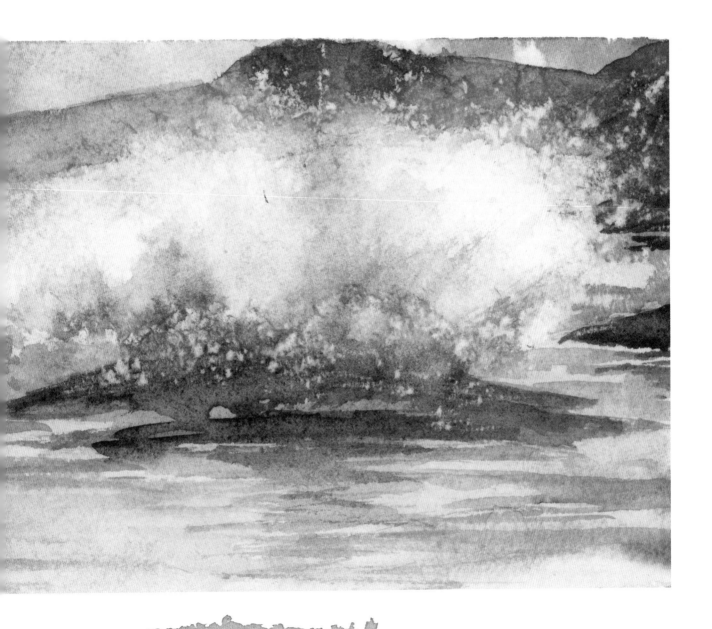

STEP FOUR

For the last step, once the painting is dry, grab an X-Acto knife or something sharp (a calligraphy nib will also work). Dragging the sharp object along on its side, gently scrape off some pigment to create speckles of light on the waves, on the ripples, and on the crash of the wave.

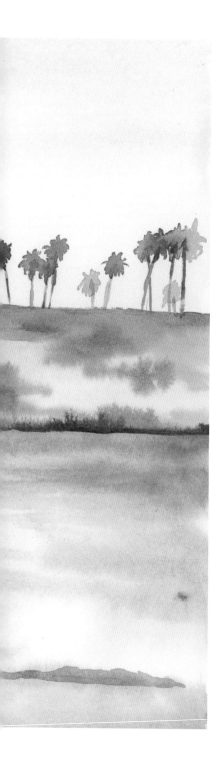

SHAW'S COVE
WOW

This little beach is a gem. It's one of my favorite stops whenever I'm in Laguna Beach, California. I love walking down the steep steps in the morning with my coffee to watch the mist clear off the waves and rocks. It's truly magical, so I had to include it in my book!

SKETCH

Lightly sketch in a horizon line about two thirds of the way up your paper. Then sketch in the cliff side that comes around the cove, keeping the bottom of this cliff parallel with the horizon line so it won't look like it's sinking.

STEP ONE

Mix up a really light wash using mostly
water, Prussian Blue, and a touch of Mars
Black. Spread that wash over the sky
and bay, avoiding yet surrounding the
cliff area.

Make another mix of Prussian Blue and
Mars Black, with less water this time, and,
while your wash is still wet, paint waves
on top of the ocean, using zigzags that
get lighter and thinner as you move back
toward the horizon. Let this dry.

STEP TWO

Make a light mixture of Yellow Ochre, Burnt Umber, and Mars Black and paint the cliff. While it's still wet, poke in a darker version of this smoky brown color with Burnt Umber and Mars Black to define it a little bit more and to add texture on the cliff side. Do the same for the rocks in the middle of the sea. Use a mixture of Burnt Umber and Mars Black for the trunks of the palm trees along the top of the cliff, and use Sap Green, Mars Black, and your size 2 brush to paint the palm fronds. Keep these strokes focused on C curves and use just the tip of the brush to create dainty, fine lines for the palm fronds. Vary the height of the palm trees for a more natural appearance.

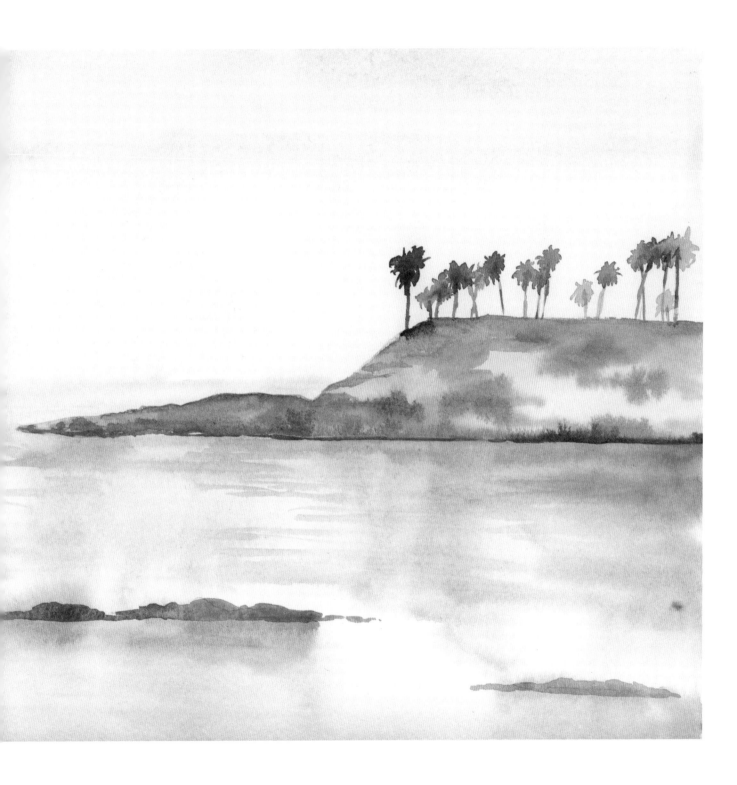

SEAGULL

Detailed Sketch

We can't get through a book on oceans without painting a seagull! One of my first memories as a child was having my burrito stolen by a seagull—I was terribly sad! But these iconic beach creatures are an important part of the ocean's ecosystem, so let's start with sketching a bird on a post in the water. Just like everything else, it's best to break down this subject into basic shapes first before doing the contour.

SKETCH

If you look closely at my sketch, you'll see that the chest and belly area of the bird is a circle, with another oval shape just a couple inches above the circle for the belly. The two legs should align with the width of the neck, and the eye line will be right on the center line of the beak. I've added some crosshatching and shading to the bottom area on the belly and on the head of the seagull to give some fine feather details, and wrinkles and cracks on the legs and post. Sometimes it's fun to add your detail in the sketch and let that show through your watercolor, but if you prefer adding this detail at the end with paint, do what feels best to you.

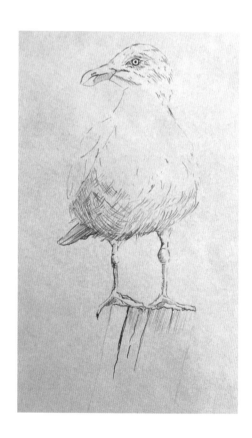

STEP ONE

Grab your size 6 round brush and wet it with a very transparent mixture of Yellow Ochre and a touch of Carbon Black. Before you put this on your paper—let me reiterate—this should be mostly water and the tiniest touch of color to create an off-white look for the belly area. Once you have your color wash, paint this into the entire belly and chest area and even onto some of the wings. While that is still wet, load your brush up with a creamy, thicker mixture of Carbon Black and a touch of Burnt Umber and paint in the wings and tail. Make sure not to go too far into the belly with this darker color and just barely graze, or touch, the edge of the wash area to let that softly bloom, or bleed, into the wash.

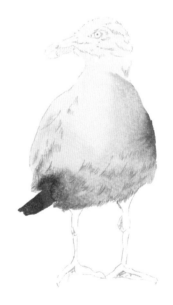

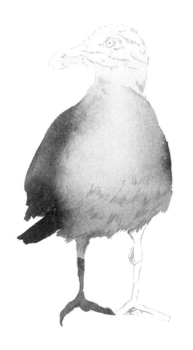

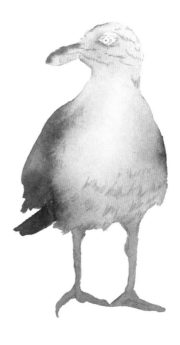

STEPS TWO AND THREE

Next, let's begin to paint in the rest of the base layers on the seagull's body, starting with his legs. Mix up a medium transparency, or milky consistency ratio, of Primary Yellow, Permanent Orange, and a touch of Burnt Umber and paint that in to his legs. Apply a similar mixture, but with a little more yellow and water, to the beak and then, using WOW, poke in a touch of your darker orange color on the top of the beak.

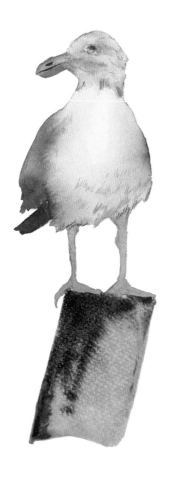

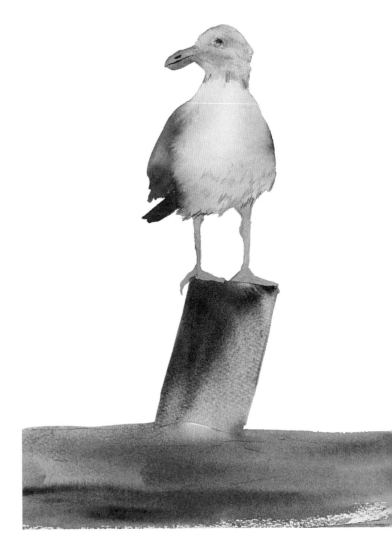

STEP FOUR

Once the base layer of the seagull's face and head is dry, use your size 2 brush and a light wash of Burnt Umber and Primary Yellow to outline the shape of the seagull's eye. Make sure that this is very transparent and light because we'll be adding details in a later step. Then apply a wash of water on the pole the seagull is resting on and poke in a creamy consistency of Burnt Umber and Carbon Black on the left side of the piece of wood while the base is still wet.

STEP FIVE

Next, while the pole is still wet and using a thicker mixture of Primary Blue Cyan or any color you have that's close to turquoise, sweep in a little hint of water at the base of your paper using a size 16 round brush or a 1-inch mottler or wash brush and let the blues and browns bleed into each other for a fun, loose look.

STEP SIX

Last, let's add all the little details to our seagull and wood post, using a size 2 round brush and a thicker mixture of Burnt Umber. Paint in the outline of the seagull's eye and the details in his beak. Add more depth to the bird's wings using a creamy consistency of Carbon Black and a touch of Burnt Umber and finally, some line details to the wood post.

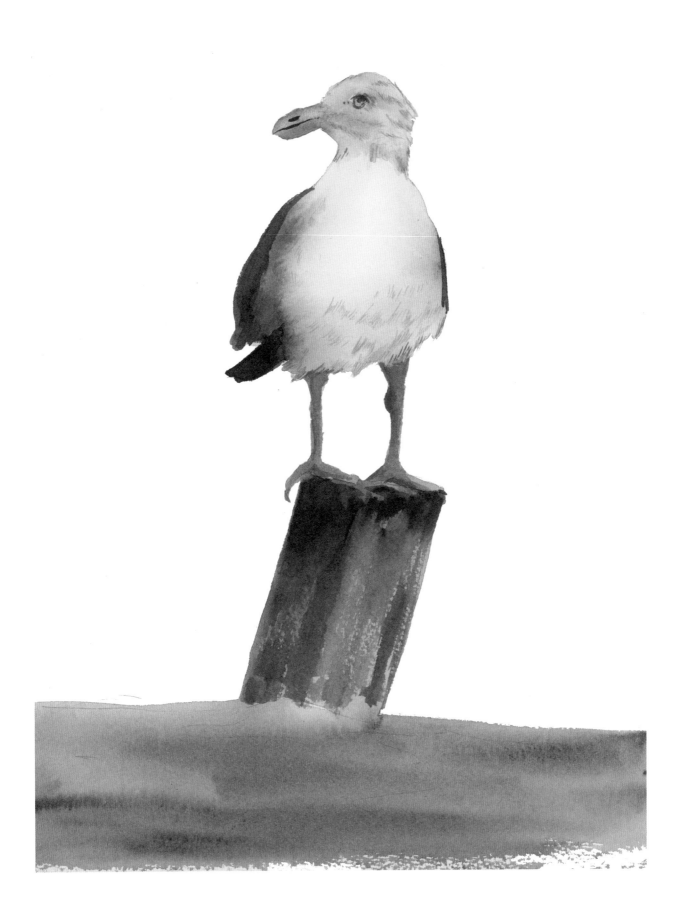

FISHING BOAT AT SUNSET

Reflection on Water

Now that we've painted water a few times, let's get a little more advanced and add a large fishing boat at sunset and have some fun painting colorful reflections on the water. To start, let's practice sketching the fishing boat. Most people, when approaching a subject like this, would start by sketching the contour, or outline, of the boat. But this can get tricky and make for a wonky-looking fishing boat, especially if you're not super comfortable with sketching. I'm going to show you an easier way.

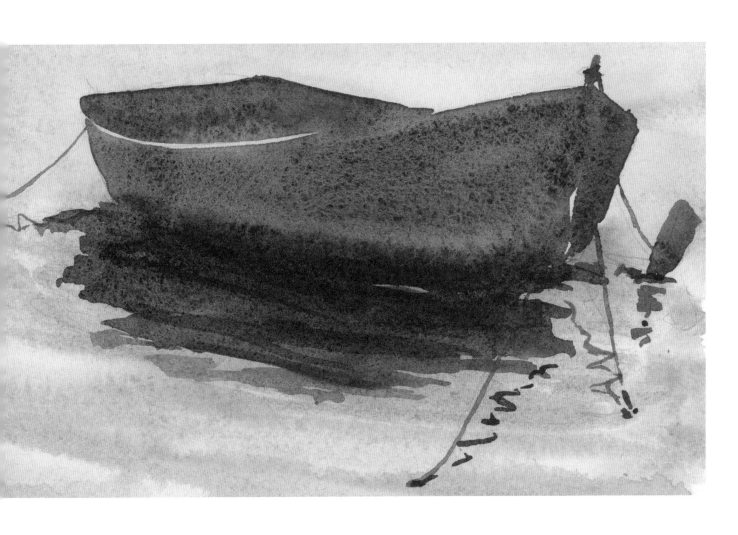

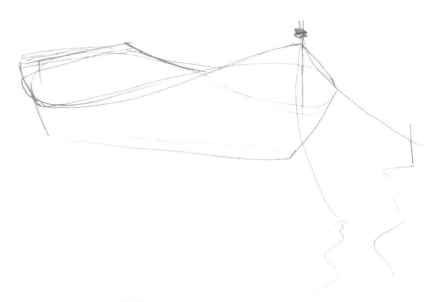

SKETCH

First, lightly sketch in the horizon line about two thirds of the way up your paper. To sketch the boat, we'll begin with a figure 8: About a third of the way down the paper from the horizon and just off to the right side, lightly sketch a sideways 8. Next, for the sides of the boat, draw angled lines straight down from the right and left ends of the 8. Now pencil in the top edge, or rail, of the boat, connecting the back and front of the 8. You can then sketch in the details, like the planks of wood on the side and the boat rope dropping into the ocean where it's tied off to an old dock pole. Now it's time to paint!

STEP ONE

For the base layer of this painting, make a really light mix of Cadmium Orange with just a little touch of Cobalt Blue and paint this light peachy color all over the sky. Then add more Cobalt Blue and Scarlet Lake to this mixture to get a smoky violet color. Sprinkle in dots of clouds using this color and also some touches of Yellow Ochre and Lemon Yellow Deep. For a deeper sunset color, add some Cobalt Blue and Prussian Blue here and there throughout the sky to create the effect of clouds and streaks. Leave a good amount of orange showing through the purples, blues, and yellows, and use yellow sparingly so that you have the speckled WOW effect amid the orange-purple, blue, and yellow. Once you are finished adding those pigments, and while the paint is still wet, take a clean, dry size 16 round brush or a paper towel and lift some of the color off to create soft white clouds. Go from the edges inward and kind of roll your brush around to go from thick to thin, tapering off toward the center of the sky.

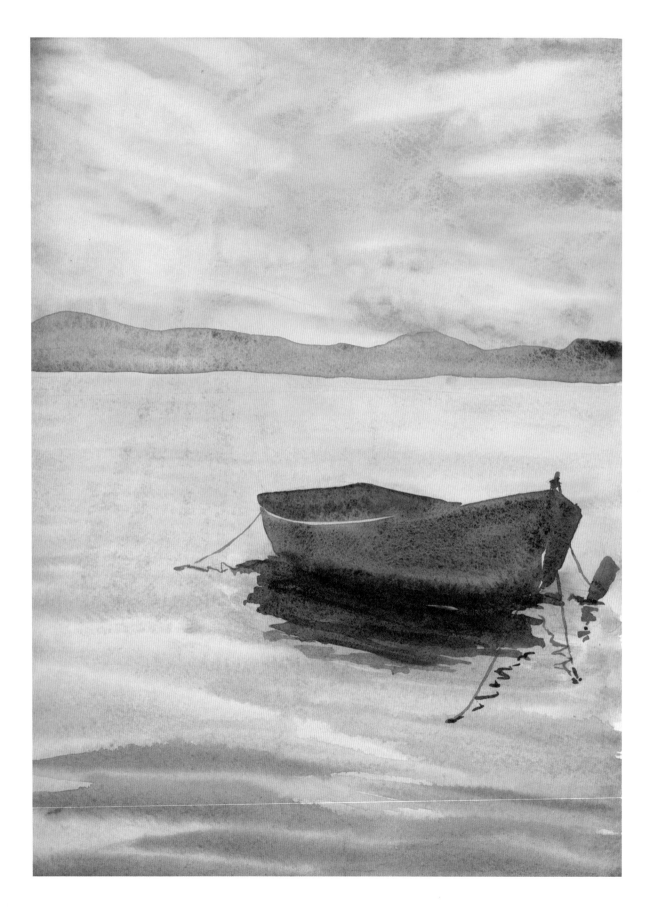

STEP TWO

Next, do the same thing with the ocean. Lay down a wet wash of Cadmium Orange with a touch of Cobalt Blue wash, then start painting waves on the water, gradually increasing the amount of Cobalt Blue into the Cadmium Orange and getting darker and darker with each layer. As this is all WOW, you'll have to work quickly. Make the waves darker and bigger toward the bottom of your paper, and thinner and lighter as they move toward the horizon.

Mix Cobalt Blue, Cadmium Orange, and Scarlet Lake for a musky smoky purple color and lay that down for the mountains or island—whatever's in the distance. Mix Cadmium Orange, Cobalt Blue, Scarlet Lake, and some Mars Black for the boat. Paint the boat, making sure to leave a thin gap of white space on the rail, separating the inside of the boat from the outside. Darken that color even more with Mars Black and paint the boat's reflection. Then, using this same dark mix and the tip of your size 2 brush, paint the ropes and ripples in the water.

SAILBOAT

Painting "White"

In the same way you painted a fishing boat from a basic shape (page 146), let's discuss how to sketch and paint a sailboat.

SKETCH

We're going to start with two C curves for the edges of the sail, creating curved sides for a triangle shape, then we'll use a straight line at the bottom to complete the triangle. Once your sail is drawn, lightly pencil in a straight line splitting it into two parts. Next, draw the boat portion of the sailboat. Because the perspective, or viewpoint, of this piece is more eye level with the boat than a view from above, we won't see the figure 8 shape as much and it will be more of a slim oval for the opening, or top of the boat. Once you have drawn that oval shape, pencil in some shorter straight lines on the ends of the oval that point in toward each other slightly, then scribble in some water and wave shapes at the base of the boat.

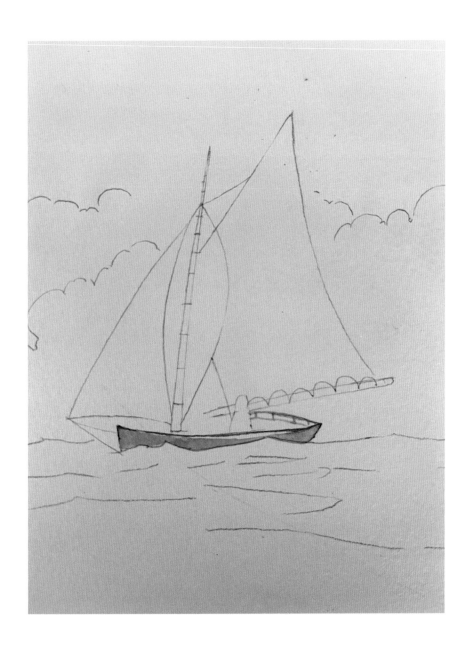

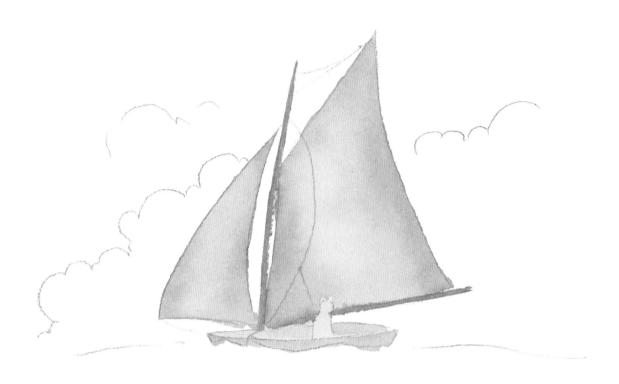

STEP ONE

Once you have your sketch worked out, paint in a very transparent wash of an off-white color, using just a touch of Yellow Ochre and Burnt Umber with lots of water. Apply this to your sails using a size 2 or size 6 brush. Use the same off-white/gray wash to paint in the base layer on the boat.

STEP TWO

Next, using your size 2 round brush, mix a milky consistency of Yellow Ochre with a touch of Permanent Orange for the mast and boom of the sailboat.

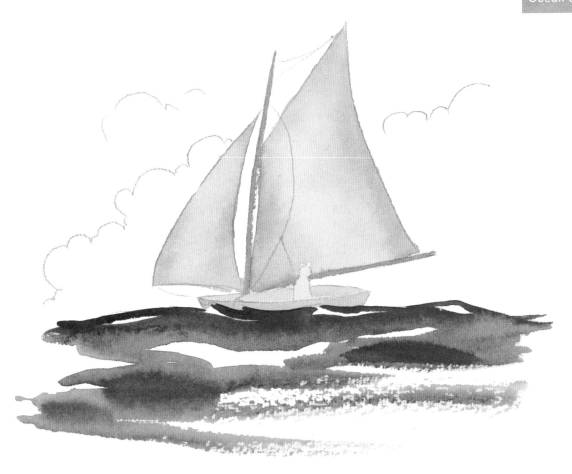

STEP THREE

While the boat is drying, grab your size 6
round brush and a very dry consistency of
Primary Blue Cyan, and paint in some water
strokes. Make sure this consistency is very
dry and has only a touch of water to get that
sparkly look for your ocean.

STEP FOUR

On your size 2 brush, grab some Prussian Blue
and paint in some darker details on the water
while the turquoise base layer is still mostly wet.

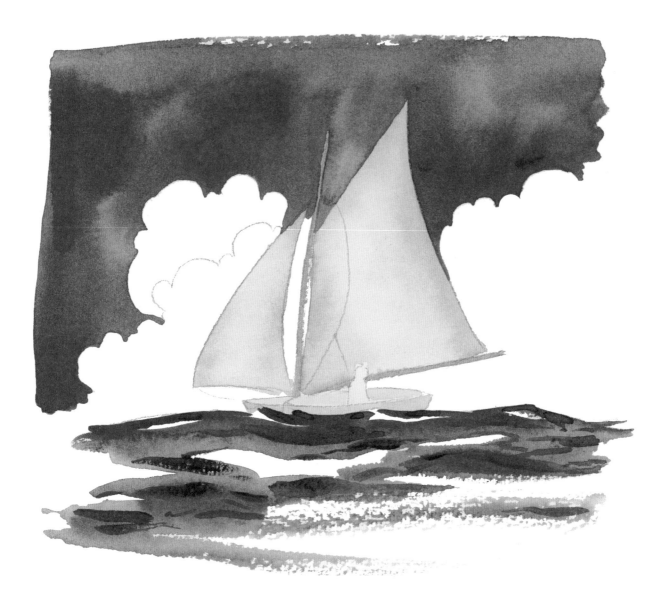

STEP FIVE

Before adding any details to the sailboat, let's move to the sky. With a medium wash of Cerulean Blue and Primary Blue Cyan, create a rough edge to the sky for a unique look, and paint in the area just above the clouds, avoiding painting the clouds or the sailboat.

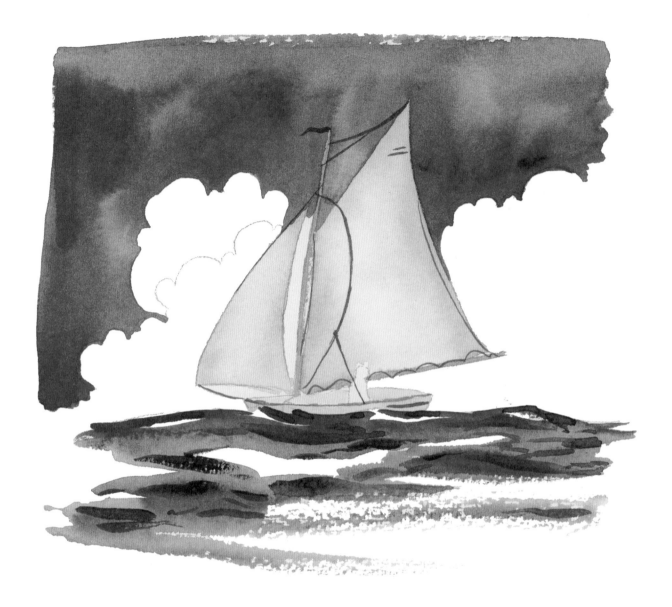

STEP SIX

For the second-to-last step, I've mixed up a
dark charcoal gray using Carbon Black and
a touch of Burnt Umber to outline the details
of the sailboat with tiny hash marks on the
sail, following the curve of the sail, and adding
mast and boom details with the same color.

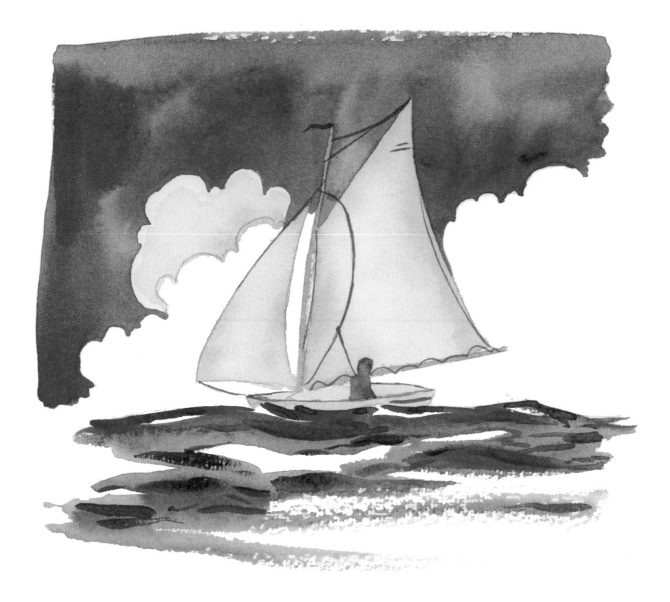

STEP SEVEN

Last, but not least, paint in a silhouette of a person in your sailboat using the same mixture and consistency of black and brown and your size 2 round brush. You really don't need to be super exact with this painterly style for people—simply paint in an oval/circular shape and pull it down into a rectangle shape for the body. We'll cover how to render painterly people in landscapes in more detail in the next chapter!

Chapter Five
PAINTERLY
LANDSCAPES

Now that we've gone deep into technique and more complex
subjects, let's strip that all away. Loose, or painterly, landscape
painting doesn't necessarily mean "easier "; oftentimes it can
be much harder. Painting in this style means you will need to rely
more on your intuition, knowledge of color theory, and harmony—
and just let it flow!

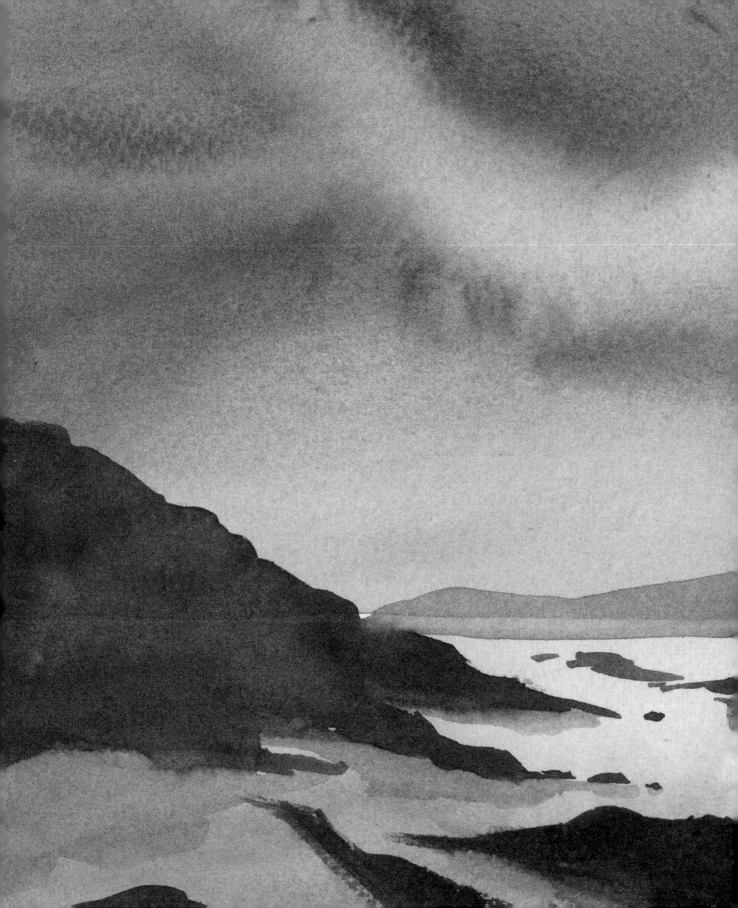

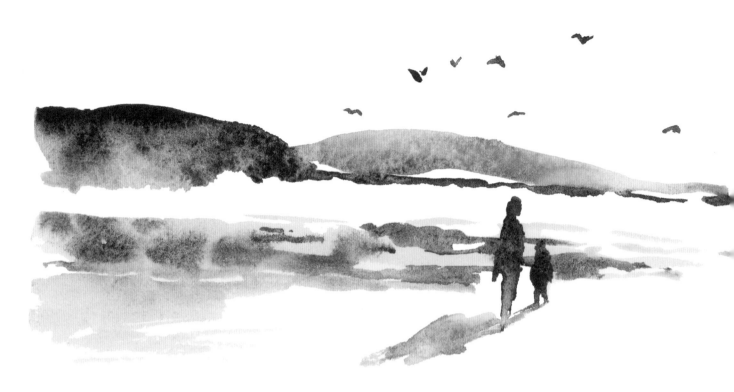

FIGURES

Dry-brush Effect

In this section we're going to practice figures
and really basic brushstrokes. Using a dry
brush loaded with just barely damp pigment
is a great way to naturally show reflections
and texture in your paintings and is one of
my favorite ways to paint abstract seaside
landscapes!

STEP ONE

Load up your size 6 brush—or, if you're
working larger, you can go up to your size 16
brush—with a lot of Mars Black and barely
any water. Lightly paint some flat strokes using
the belly of the brush and dragging it across,
practicing big wide strokes, back and forth.
Let the texture of the paper show through
the dry pigment. This creates the look of light
sparkling on water.

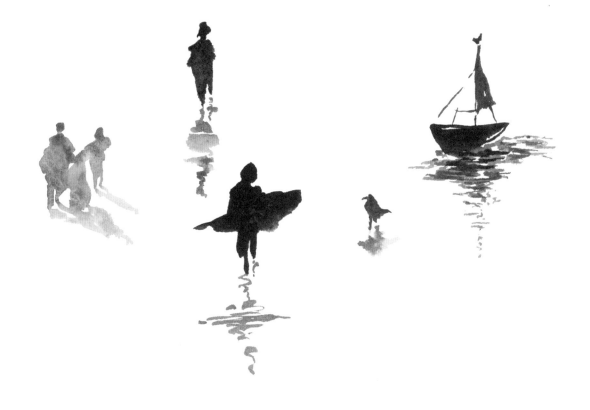

STEP TWO

Now we'll practice some figures. Load up a size 6 brush with a little bit more water and Mars Black. Using the side of the belly of your size 6 brush, paint basic shapes, very loose painterly style figures. Start with an oval for a head, followed by a square that tapers at the waist of the figure, and then add two legs. Try varying the length of the legs to show that the figure is walking. Paint these figures quickly and freely, as if you were sketching this in a journal. Add squiggly lines for reflections using a smaller brush and slightly lighter color. Keep this really loose, based on simple shapes, and practice! Try adding in some fun objects such as a surfboard, birds, or a beach towel! Keep this incredibly "sketchy" and don't overthink it. It's really just scribbling on paper with a paintbrush.

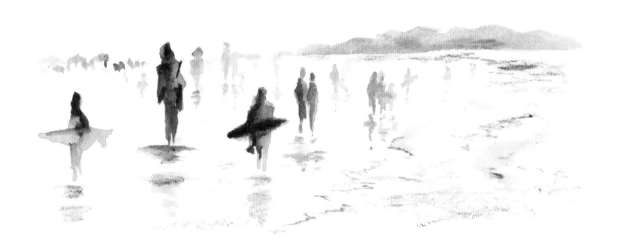

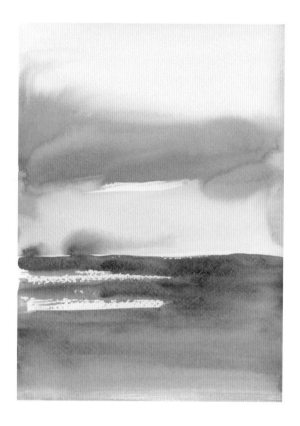

SUNSET
Two Layers

This painting takes me right to the beaches of Hawaii: a beautiful, tropical sunset viewed through the trees. For our abstract sunset, we'll start with the sky.

STEP ONE

Use Lemon Yellow Deep, Cadmium Orange, and Opera Rose and paint the sky boldly, letting the colors bleed into one another. Do this very quickly with a really big brush, either a wash brush or your size 16 brush. Leave a thin gap of white space at the horizon and paint the ocean using a darker mixture of Prussian Blue and Mars Black, and using dry-brush technique to let some speckled light come through. Make your wash lighter and lighter by adding more water as you work your way down the paper. Wait for this layer to dry completely.

STEP TWO

Once the base layer is dry, paint the palm fronds using Mars Black: Using black shows that the palm is backlit, or silhouetted. Load your size 6 brush with Mars Black—a really thick but still wet mixture of Mars Black—and paint in a thin C curve across the width of your paper. Using the tip of your brush, paint in some leaves on your palm frond: Start your brushstroke using just the tip; then, as you paint, press down to create the wide part of the frond, and as you get to the end of the frond slowly lift your brush to create the tapered end. This is called a compound stroke and is something I discuss thoroughly in my first book. The pressure and release of pressure on the hair of the brush is what helps the brush expand and then gradually come back to a point, creating the perfect leaf shape! Crisscross some of your leaves showing that there's some wind blowing.

INTO THE HORIZON

Perspective and Horizon Lines

This painting is going to focus on vanishing point perspective. As you look out at the beach ahead of you, the shore curves and gets narrower as it nears the horizon, creating a sense of distance. The beach looks like it goes on forever.

STEP ONE

We're not going to draw our scene first, so picture your horizon line just above the middle of your paper. The beach's vanishing point is on that line. Use your size 6 brush and some Sap Green and Yellow Ochre and paint in a hill or cliff on the left side of your paper on the horizon line. We're still painting in an abstract style, so don't worry too much about lining it up perfectly. Clean off your brush and load it up with Yellow Ochre for a C curve that comes forward from the horizon on the left, and then another curve on the right that points toward the same vanishing point, creating an open path on the bottom-left-hand corner of the paper; this is the beach. Mix Yellow Ochre and water with some Burnt Umber and use this to paint it.

STEP TWO

From here, everything is going to be painted very quickly and loosely to create some bleeds between the water and shore, sky, and trees. Using the same size 6 brush, load it up with Phthalo Turquoise and paint the ocean, stopping at the horizon. Barely touch, or graze, the shore with your turquoise pigment to create a little bleed and then paint in some trees on the hillside using a dark mixture of Sap Green and Mars Black.

While this is drying, grab your size 6 brush and paint your sky. I chose to paint a sunset here because the pinks and oranges complement the greens and blues. Use WOW technique to smoothly blend these colors.

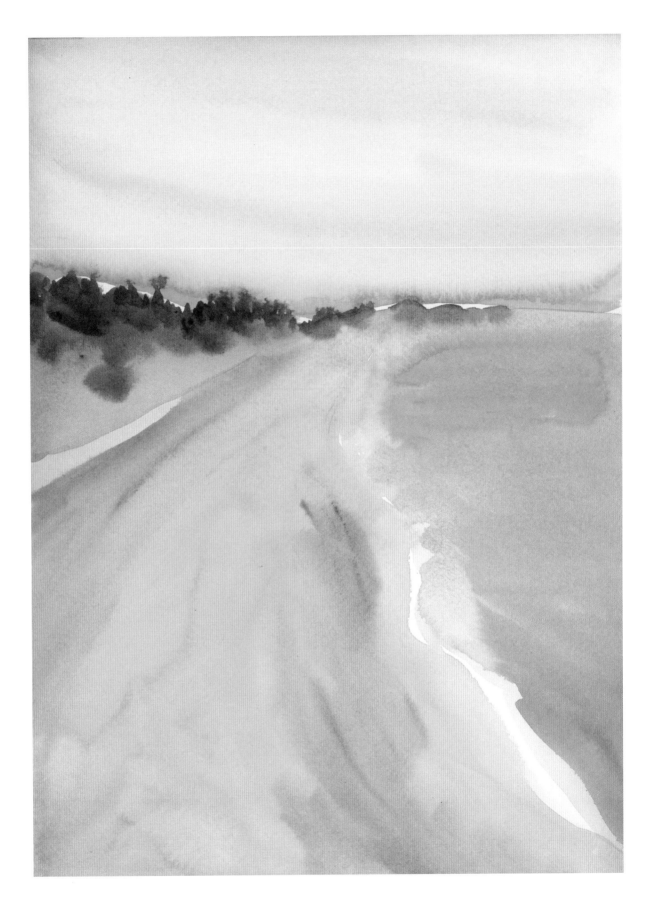

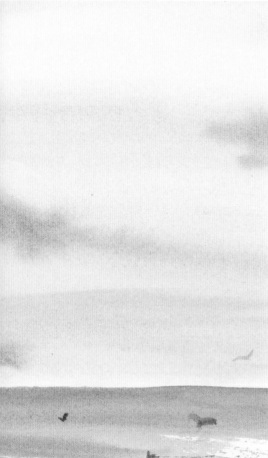

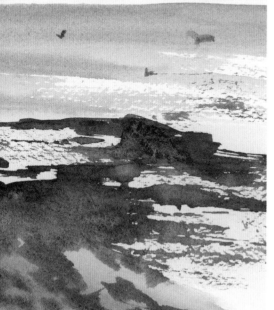

CARMEL-BY-THE-SEA

Reflections

For one of our final lessons in this book, I wanted to paint one of the most stunning coastlines in all of California: Carmel-by-the-Sea. Picture driving north on California Highway 1 on a misty, overcast day, hearing the bark of seals and the call of seagulls echoing in the cliffs. Pulling over on the shoulder is a must here. It's the most stunning drive and is truly so peaceful. To paint this vision, we're going to continue practicing loose, painterly strokes for a loose, painterly piece.

STEP ONE

First, mix Cobalt Blue, Prussian Blue, and Mars Black with lots of water and paint the ocean. Let this completely dry. Next, starting at the horizon with a darker mix of the colors in the first wash, use dry-brush technique to paint the water, creating the effect of speckled light. As you paint down the page, use lighter and lighter hues by adding water to get those soft edges between colors. When the ocean is done, add a touch more Cobalt Blue to your mixture and apply a wash over the sky. Add a little bit more pigment here and there for a very simple cloud effect.

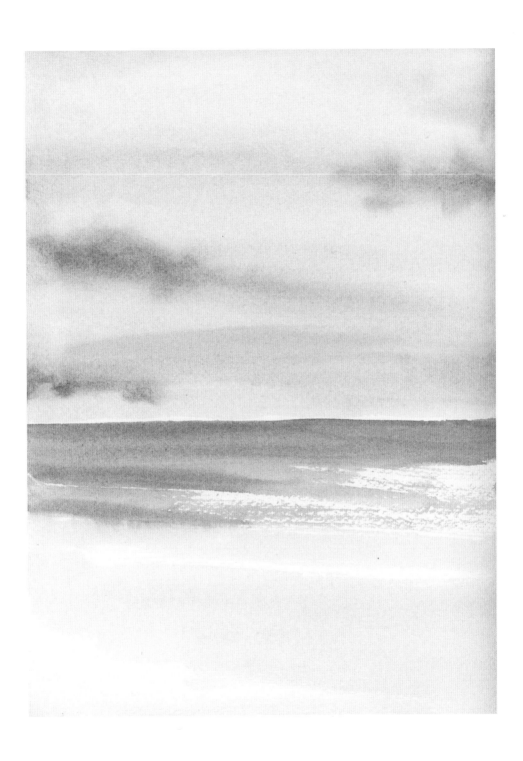

STEP TWO

For the next layer, paint some rocks near the shore using Yellow Ochre and a touch of Burnt Umber. Paint a dome shape in the bottom left-hand corner of your paper, then mix up a yellow-green mixture using Sap Green and Lemon Yellow Deep. Using WOW technique, apply this yellow-green mixture at the top of the brown dome. Then, using a dry brush and a dark mixture of Sap Green and Mars Black, paint in some zigzag shapes for cliffs and rocks in the ocean and get an even more speckled rocky texture by trying to use the side of the brush, flattening the belly of the brush as much as possible and pulling it across the paper. Then finish off the piece with a few painterly seagulls by creating a small *V* shape with a size 2 round brush. The closer a subject is to the foreground, the more opaque and darker it will be, while the ones in the background will usually be smaller and a lighter value.

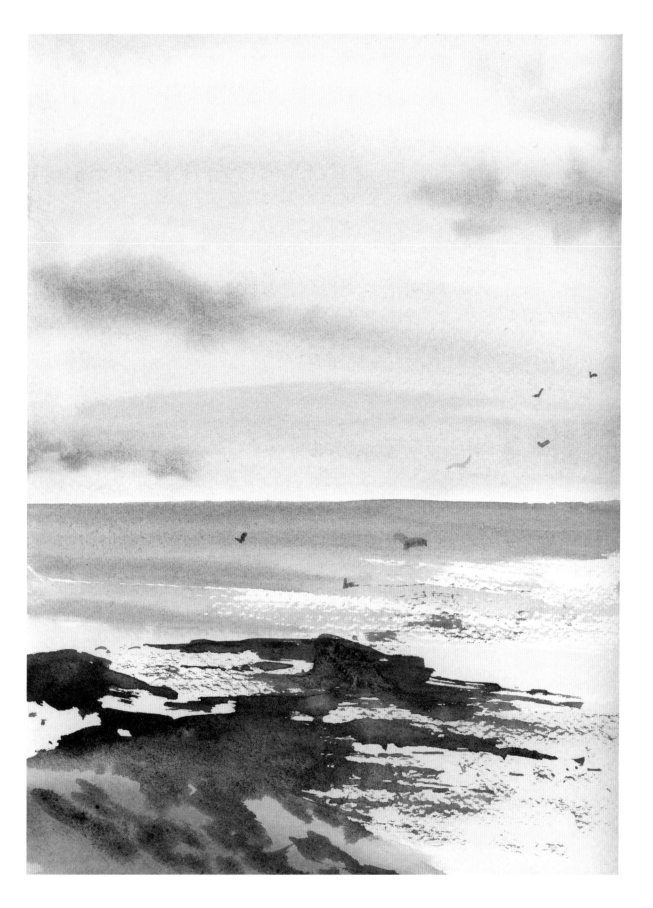

VANTAGE POINT

Perspective

For this landscape, we're going to address something a little more technical, and that is the idea of perspective. In any landscape painting, it's so important to understand the perspective, or vantage point, that we're taking inside the landscape. Are we an adult that's average height? Or are we taking the perspective of a bird on the ground? If we know where we want the viewer to look, we can then know exactly where and at what angle each detail in the water or even on land is. If we were to add trees, the gaps between each line show us how tall or deep they are. The closer and closer you get to the vantage point, the smaller and thinner the gaps between the lines become.

SKETCH

This is something I cover greatly in-depth in my course "The Art Within," and for this lesson we'll do a shoreline painting with a one-point perspective, or vantage point. So, to grasp this, grab a ruler and a pencil and sketch in a faint line horizontally across your paper. In any landscape painting or photograph, your vantage point will always fall somewhere on your horizon line. To show the distance in this piece, I wanted a shoreline that felt stretching and expansive, so I've placed a dot for my vantage point on the horizon line to the right of center. From here, using your ruler and lining it up with your vantage point, pencil in a few lines to use as guides for placing waves and the edge of the water on the shore. This is where vantage point is truly so incredibly useful, because it guides you as you place the elements of your painting.

STEP ONE

Once you have your sketch drawn, paint in a light blue wash on the ocean, leaving gaps of white space where the crash or foam of your water would be.

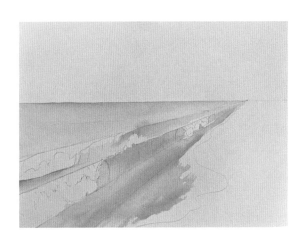

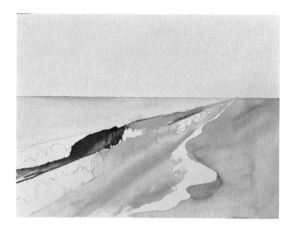

STEP TWO

While the ocean is drying, grab Yellow Ochre and a touch of Burnt Umber in a lighter wash, or coffee consistency, and paint in your sand, adding in some of the same color in a thicker consistency right up to the edge of the water to convey shadow and depth. Once you've painted in the sand, your base layer on the ocean should be mostly dry and ready for some darker color in the barrels of the waves. Use a medium, or milky, consistency of Prussian Blue and some Primary Blue Cyan for this, and be sure to leave some paper unpainted for the whitecaps and crashes of the waves.

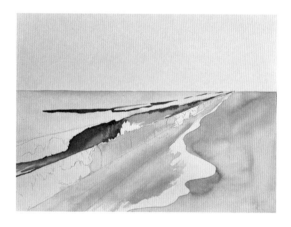

STEP THREE

Next, begin to add those medium and darker blues along the rest of the ocean, making sure that the angle of your strokes parallels your lines of perspective, always pointing to the vantage point. And use water to blend these strokes in.

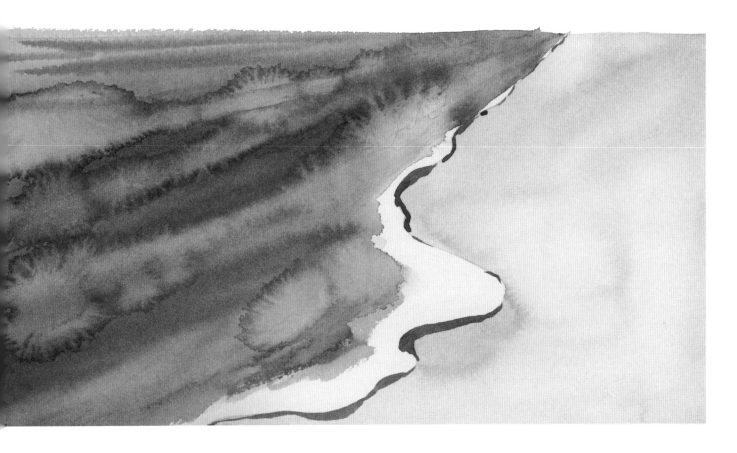

STEP FOUR

Finally, blend in your strokes with a glaze of water all along the ocean. Again, make sure to sweep your lines across, always pointing back to the vantage point to show that depth and perspective.

Conclusion

You may have painted your way through this entire book, but that doesn't mean you should stop painting oceans and sea creatures. I hope you have learned to analyze your subject's basic shapes and have been challenged to discern how the beautiful world of the ocean is structured. This way of painting not only helps you grasp the correct proportions and dimensions, but also turns you into someone who looks longer at things. Next time you visit the ocean, or any body of water, stop and look carefully at the surface and the waves. How is the light hitting them? What curves and shadow shapes do you see? What colors are reflected? Study the details in the sand, the foliage, and the creatures you find, and take in a deep breath of the seashore's calming air.

I hope this will help you slow down and observe, become more patient with the process and with yourself, and, in the end, become a better painter. Don't get discouraged when you make mistakes; be grateful. Each mistake is helping you become that much better at your craft, if you're able to learn from it and adapt. Beyond this book, I challenge you to find a new way of looking at the ocean—it's grandeur, beauty, and depth—and recognize how much this world and all the animals in it truly deserve our respect. If you're on social media, Instagram is such a great community for sharing your work and encouraging other artists following along. Make sure to hashtag #EverydayWatercolorSeashores when you post your work to stay inspired and continue to paint more!

 To take your watercolor seashores and subjects to the next level, check out my video course that covers similar projects as this book but with a twist!

Acknowledgments

To John and Myles, who constantly teach me to play and keep exploring.

Thank you to the incredible team at Ten Speed Press, my wonderful literary agent, Kimberly Brower, for believing in me, and for all the support and help from my girl Kelly Martin!

About the Author

Jenna Rainey is a watercolor artist, surface pattern designer, and illustrator, born and raised in Southern California. What started as a stress-relieving activity during a desk job in finance quickly turned into the creative business of her dreams. Art unlocked something in Jenna that changed every aspect of her life. She now inspires hundreds of thousands of people to find and express their own creative voice through her YouTube Channel, bestselling watercolor how-to books, art retreats, and online courses.

Jenna's work is inspired mostly by nature, travel photos, architecture, and textiles. Her signature vibrant loose-style florals, landscapes, and geometric designs are found in collaborations with brands like Blue Sky for Staples, Crate & Kids, Pixar, Lovevery, Toki Mats, Zola, and more.

Jenna's best advice is as follows: (1) Create something today, even if it sucks, because consistent practice, muscle memory, and getting into flow state will help you create your best original work; and (2) high-quality art supplies can really make a big difference, so start building your collection as you're able. There's something really magical about WOW watercolor pigment blooming on textured cold-pressed paper!

See more of Jenna's work on Instagram (@jennarainey), YouTube (jennarainey.com/youtube), and her website (jennarainey.com).

Index

Typefaces: Great Lakes Lettering's Mon Voir, Jim Wasco's
Harmonia Sans, and Swiss Typefaces' Euclid Circular.

Library of Congress Cataloging-in-Publication Data
Names: Rainey, Jenna, 1989- author.
Title: Everyday watercolor seashores : a modern guide to painting shells,
 creatures, and beaches, step by step / Jenna Rainey.
Description: First edition. | California : Watson-Guptill, [2024] | Includes
 index. | Summary: "From the Instagram artist behind Everyday Watercolor
 comes a beautiful step-by-step guide to painting shells, sea creatures, and
 oceanscapes-in her effortlessly modern style"-- Provided by publisher.
Identifiers: LCCN 2023005446 (print) | LCCN 2023005447 (ebook) | ISBN
 9781984856814 (trade paperback) | ISBN 9781984856821 (ebook)
Subjects: LCSH: Seashore in art. | Watercolor painting--Technique.
Classification: LCC ND2237 .R35 2024 (print) | LCC ND2237 (ebook) | DDC
 751.42/243--dc23/eng/20230524
LC record available at https://lccn.loc.gov/2023005446
LC ebook record available at https://lccn.loc.gov/2023005447

Trade Paperback ISBN: 978-1-9848-5681-4
eBook ISBN: 978-1-9848-5682-1

Printed in China

Acquiring editor: Kaitlin Ketchum | Project editor: Kim Keller
Production editor: Ashley Pierce
Designer: Nicole Sarry | Art director: Emma Campion
Production designers: Mari Gill and Faith Hague
Production manager: Jane Chinn
Copyeditor: Laura Starrett | Proofreader: Jane Hardick
Marketer: Andrea Portanova

10 9 8 7 6 5 4 3 2 1

First Edition